IMAGES
of America

AROUND MOMENCE

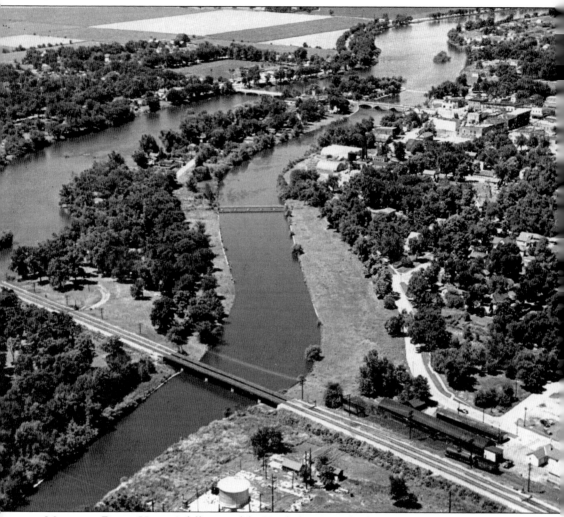

MOMENCE RIVER VIEW. A full view of the Kankakee River looking west reveals the Chicago and Eastern Illinois Railroad, originally named the Chicago, Danville and Vincennes, built in 1870. This rail line drew business from the older Illinois Central Railroad upon its completion. The north and south bridges, footbridge, island, and dam on the north branch demonstrate a 200-year effort to embrace the river that created the city of Momence. (Courtesy of Butterfield Studios.)

On the cover: **VAIL'S CABIN.** A. S. "Uncle Sid" Vail, known as the first citizen of Momence, hosts a river excursion of locally prominent citizens including Mr. and Mrs. John Smith with children, Charles Smith, Mr. and Mrs. William Lunt Sr., and Dr. and Mrs. Green. Vail is the white-whiskered gentleman in the rear. The cabin was built around the beginning of the 20th century and can still be found along the banks of the Kankakee River east of Momence. It is now covered with modern-day siding and has been moved from its original site, yet it remains in its original state inside the structure. (Courtesy of Sue Butterfield.)

IMAGES
of America

AROUND MOMENCE

Kevin McNulty Sr.

ARCADIA
PUBLISHING

Copyright © 2007 by Kevin McNulty Sr.
ISBN 978-0-7385-5128-9

Published by Arcadia Publishing
Charleston, South Carolina

Printed in the United States of America

Library of Congress Control Number: 2006940475

For all general information contact Arcadia Publishing at:
Telephone 843-853-2070
Fax 843-853-0044
E-mail sales@arcadiapublishing.com
For customer service and orders:
Toll-Free 1-888-313-2665

Visit us on the Internet at www.arcadiapublishing.com

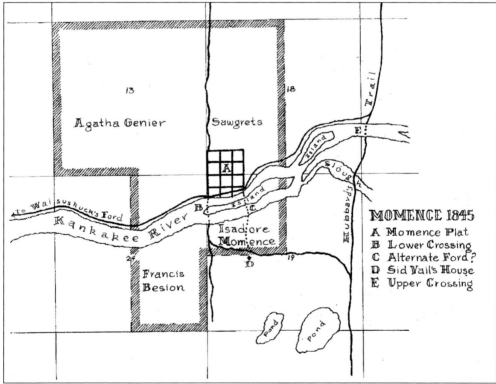

FIRST PLAT MAP. This map, sketched by author and Kankakee County historian Vic Johnson, reveals the location of early landmarks during the frontier days of Momence, the oldest settlement in northeast Illinois. At the time, the Cook County line extended to the Kankakee River. Will County began south of the river. Kankakee County was not formed until 1853. (Courtesy of James V. Johnson.)

Contents

Acknowledgments — 6

Introduction — 7

1. The Kankakee — 11

2. Old Border Town — 21

3. A World of Change — 35

4. Modern Momence — 53

5. Rural Neighbors — 69

6. Church and School — 81

7. Team Play and Melody Making — 97

8. The Festival — 111

ACKNOWLEDGMENTS

The photographs in this book come from the personal collections of dozens of people in and around Momence. Special thanks to the City of Momence, the Edward Chipman Public Library, Main Street Momence, the Momence Fire Department, Momence Community Unit School District No. 1, St. Patrick's Church and School, the Grant Park Historical Society, Grant Park Community Unit School District No. 6, St. George Church, St. George Community Consolidated School District No. 258, the Momence Historical House, Momence Township, the *Progress Reporter*, the *Daily Journal*, the Momence Chamber of Commerce, the Momence Theatre Friends, and the Momence Gladiolas Festival.

 I would like to thank my nephew Kyle Smith for editing the book, Jean Stetson for her exceptional assistance with the library archives, Jim LaMotte for his enthusiastic support, Mal Peterson for her depth of information, and Bill Munyon for his inspired stories and love of Momence. I am also indebted to my uncle Vic Johnson for his lifetime of inspiration and knowledge of Kankakee County, including Momence.

 I would like to offer special appreciation to some key individuals who assisted me with the book, including Jean Stetson, Jim LaMotte, Marilyn "Mal" Peterson, Joanne Herman, Bill and Phyllis Munyon, Bill Buck, Brian Prairie, Paul Hyrup, Sue Butterfield, Vic Johnson, Lorraine McNulty, Mary Cantwell, Isabel "Issy" Prairie, Mark Noller, and Rev. Kenneth Yarno.

 I would also like to personally thank a number of individuals who were of particular help to me in compiling this book, including Jim and Elaine Saindon, Vern Koelling, Velda Case, Vickie Carpenter Sommer, Rick Preston, Rick Digitz, Rene Wright, Betty "Skip" Dionne, Helen O'Cull, Clara Butterfield, Kay LaChappel, Karen DuMontelle, Leonard "Lum" Tomaski, Andrea Shopf, JoAnne McCracken, Margaret Clifton, Bus Trudeau, Gary Carruthers, Kay Fite Laue, Velma Henniger, Helen Backus, Ann Murray Hall, and Eugene Sievers III.

 Finally I would like to thank the people of Momence I have known, past and present, who shaped my life, my love for music, and my interest in history. May your greatest days be ahead of you.

INTRODUCTION

Momence, Illinois, located in the northeastern part of the Prairie State, was the beneficiary of a unique ecological water system through its latitudinal axis and a major north-south pathway of commerce that developed as a result of some important river crossing of irresistible beauty. In the early 1800s, the father of Chicago, Gurdon Hubbard, as well as other traders of the day, drove teams of men, oxen, and horses from the fertile hunting grounds of Danville, Illinois, and the neighboring Wabash Valley to South Water Street, then a common reference to the large settlement north of Momence that became Chicago. They crossed the imposing Kankakee River at Momence via a series of fords or shallow crossing points resulting in the gradual formation of a river settlement without a name. At this time, the Cook-Will County line was the Kankakee River. Kankakee County had not yet been incorporated.

To the east, some six miles from the upper crossing lay the most significant natural hunting grounds in the Midwest called Beaver Lake. Early testimony of those who hunted, trapped, and fished the great marshes of the Kankakee described it as more abundant than any other spot in the United States. At the point where the marsh crossed the state line, twisted tributaries formed and deposited into a quiet, more definable channel that overflowed into numerous backwater areas, shallow bayous, marshes, and around a regular dropping of islands that characterizes the river to this day. "The island" at Momence is as much a part of the local nomenclature as any other man-made structure in town.

Topographical maps reveal the marked change in the river once it arrives at Momence. The twisted pattern it follows east of town, following even greater fragmentation upstream in Indiana that was subsequently eliminated by channel work around 1910, demonstrates how Momence was the node between an agricultural prairie to its west and a luscious fish and game sanctuary to the east. Add to that the ability to cross the river at one of the shallow crossings at Momence and it is no wonder that this area became attractive to the earliest settlers in northeastern Illinois.

In his book, *Tales of an Old "Boarder Town" and along the Kankakee*, Burt E. Burroughs articulates beautifully the strong connection between the geography of a region and the personality of the people who inhabit it. He links the early people of Momence to their natural surroundings, forming a sort of psychological bedrock on which generations of diverse Momence people find a commonality. "Situated on the river and on the edge of that vast marsh paradise of nearby Indiana, it was for years a sort of capital for the country roundabout, the focal point towards which the thoughts and steps of the wilderness population often turned. Here supplies of powder and shot were to be had and here, also, a fellow with a 'thirst' could deluge the inner man to his heart's content with no one to say him nay, so long as he had a raccoon or mink pelt

left to pay for it." Keep in mind that this describes the second group of people to live in the area. The earliest settlers were merely taking their place alongside the Potawatomi Indians who had long seen the value of the great river and its natural resources.

But another significant wave of settlers would also be drawn to Momence. They were a somewhat more aristocratic set from the east. They came from New York, New Hampshire, or directly from Europe. They were storekeepers, craftsmen, businessmen, and professionals. They too took their place alongside the more rugged frontier immigrant from Kentucky, Indiana, or Tennessee. Add to this mix a special spicing of French voyagers, professional trappers, and others finding their way west and one has the makings of a classic American melting pot community forced to unify by the overwhelming power of their natural habitat. Indeed, eastern businessmen became lovers of the hunt and vagabond frontiersmen built modern homes and created businesses in town.

In 1833, William Lacy built a log cabin on one of the natural fords of the Kankakee just east of Momence known to locals as the "upper crossing" or Westport. A year later, Asher Sargeant built the first habitation a mile west of Lacy on the present site of Momence. In 1836 came A. S. Vail, who would be known as the first citizen of Momence. Walter B. Hess and W. W. Parish arrived in 1839. The descendants of both of these men have impacted the city to this present day. In the mid-1800s, the American Indians departed the area, leaving behind many saddened local Momence citizens who had made friends with the Potawatomi according to many written accounts.

The modern railroad crossed the river at Momence following the Civil War and immediately drew business from the dominant Illinois Central. Intended and unintended changes to the river, as a result of "improvements" along with the construction of numerous bridges and dams in Momence during the late 19th and early 20th century, changed the look and depth of the river at Momence.

At the bottom of a file cabinet in the Momence Historical House, my mother and I discovered two small photo albums containing photographs taken from 1884 to 1910. The photographs are a rare historical record of two longtime buddies named LaFayette Buffington and Frank Lane. They show us an enchanting view of the river as it was before Indiana officials canalized the Great Kankakee Marsh. One can clearly sense the peace and solitude of the natural beauty of the Kankakee. We chose to dedicate the first chapter to the river through the experiences of Buffington and Lane.

Many contemporary names in Momence were present during the community's earliest days. Names such as Sherwood, Jensen, Brown, Astle, Johnson, Halpin, Clark, Nichols, Cromwell, Gelino, Butterfield, Schenk, Bukowski, Shaw, Drazy, Chamberlain, Hyrup, and many others are as familiar to locals today as they were over 150 years ago.

Large beautiful homes were built in the late 1800s in Momence, and they are well kept by their owners today. Many of these classic homes include small signage indicating the date of their construction. The homes can be found on either side of town, along the river and short distances from town along early trails like Vincennes now paved for the modern-day traveler. Architecturally, the downtown area is historic, and much of it looks similar to the way it looked 50 or 100 years ago. If there are variations, one need only look to the upper floors or the rear of buildings to see that they are of same structure.

As Momence entered the 20th century, new forces shaped its evolution. The impact of two major wars, a 10-year depression, and massive industrial modernism created challenges and opportunities for Momence as it did every community in the country. The sudden emergence of World War I in the early 20th century took local boys from Momence only to see them return and make the city more modern. As with all wars, a burst of local improvements occurred following the first war, and the automobile lead the way to American modernization in towns like Momence. Livery stables became automobile centers over time. Dirt streets were paved over with concrete.

The Depression years were clearly difficult for all Americans, but projects like the new high school and growth in civic groups bolstered the community and moved Momence forward.

Clearly some residents on surrounding farms had a bit more to eat than did those in town. But at the height of the Depression, Momence held its 100th anniversary in a grand way. With a history of celebrating life's good times that went back to their frontier days, the Momence people also launched the Gladiolas Festival at the height of tough times in 1938 at the inspiration of Roy Hess.

Like every community in America, World War II was a time of sacrifice and pause. Momence had its share of heroes who preserved the American way of life during the war. After the war, entrepreneurs, many of them veterans, created what some would say was the peak of Momence's economic strength to date. Names like DuMontelle, Astle, Speith, Therien, LaMotte, Cromwell, Reising, Thyfault, Case, Benoit, Mullady, Jensen, Mackin, Butterfield, Petkunas, Stetson, Lustig, Wheeler, Orr, and others built solid local businesses that thrived in the postwar boom years.

War babies filled Momence schools, and civic activities were at a full strength after the war. Scout troops, baseball teams, clubs, and musical groups all had full rosters during these youthful days. Every town had its own version of the "square." In Momence, teenagers drove up and down Dixie Highway with regular stops at Toot 'n Tell Us, later Dionne's, looping around Frank's on the north end and back through town.

As the 1960s waned, a world of economic change would not leave Momence untouched. Retailing was now being placed in the hands of multinational and regional brands, pricing local proprietors out of the market all across the country. Interstate development would bypass Momence, and malls consolidated shopping throughout America. In the 1970s, Momence beautified its downtown by creating antique-style imaging on storefronts to attract continued business. Today, as part of the promotional efforts during the holiday season, the local Main Street group decorates even closed stores to promote good will and support other local businesses. Momence has always understood the importance of style, as well as substance. Perhaps it is the generations of shadow boxes entered into the annual flower show that fostered this keen sense of presentation.

No review of Momence should exclude the Gladiolas Festival. People that know very little about Momence can often recall something about the Glad Fest, which is the city's trademark. Everyone from Momence has memories of this special event, and we continue to pass the experience down to our children and grandchildren. I hope you enjoy some of the rare photographs of festivals from years gone by. For those who are no longer able to return to Momence for the festival, perhaps our final chapter will serve as a print parade of memories.

While the river dominated land east of Momence, area farms existed in every direction and communities like Grant Park and St. George served as civic and religious centers. Their histories are different, but they are also linked to Momence as neighbors. At a time when retailing and manufacturing waned in town during the 1970s, farm auctions increased as costs and pricing made family farming difficult.

Today Momence and area towns are just beginning to see the movement of suburban dwellers to the exurban areas some 50 miles from Chicago's center. Urban planners and Momence civic leaders will have new challenges and opportunities as a result of the exurban growth. I hope this small effort will provide existing residents of Momence and eastern Kankakee County a look back at the great people who have come before us and provide everyone with a future vision of Momence as the next chapter of our "old border town" is written.

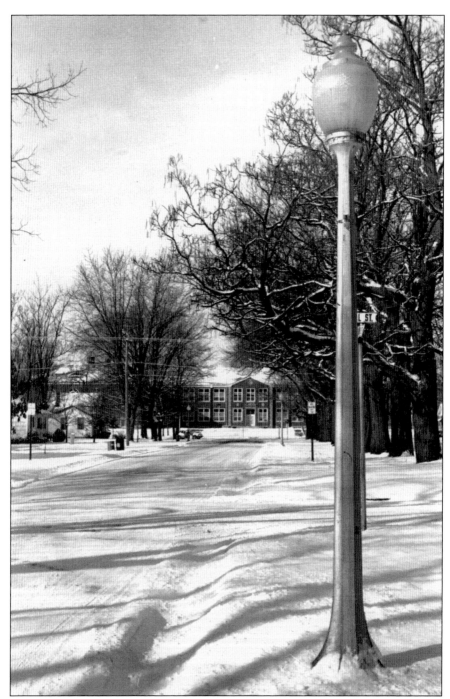

FAMILIAR WINTER SCENE. The iconic image of Momence High School at the end of Washington Street, lined by classic streetlamps, is a source of community pride and a testament to Momence people who always recognized the importance of style as well as function. Walking down the center of this street to the high school following parades each summer led one to the enchanting world of drum corps shows, flower shows, carnivals, and other thrills beyond the small-town existence. (Courtesy of the Daily Journal.)

One
THE KANKAKEE

LANE AND LAFAYETTE. Dressed in street clothes, Frank Lane and LaFayette Buffington, in their younger days, drift toward shore as their trusty hunting dog looks on. Lane owned a photo studio in town, which provided a professional-quality documentary of their days hunting, trapping, and fishing on the Kankakee River. (Courtesy of the Momence Historical House.)

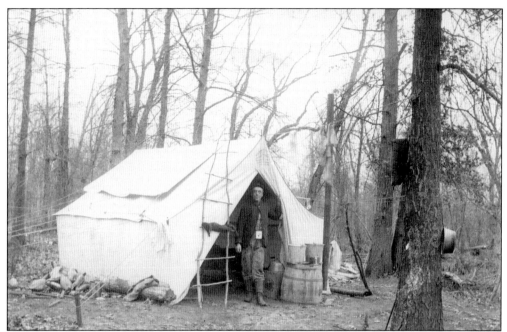

LaFayette Buffington. Buffington pauses for a photograph taken by Frank Lane. Tents used by Buffington were similar to those used during the Civil War and included a venting pipe to carry smoke and heat from the stove, which is heating their metal pot just inside the door. (Courtesy of the Momence Historical House.)

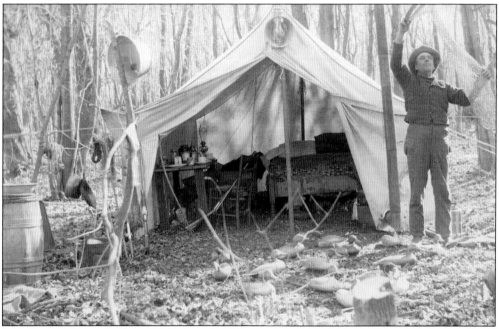

Setting up Camp. Buffington dries out his fish net or perhaps the netting used to carry multiple decoys. The photograph was taken in 1896. Absent collapsible cots in those days, outdoorsman carried full beds and other household furniture on extended trips to the backwater woods. (Courtesy of the Momence Historical House.)

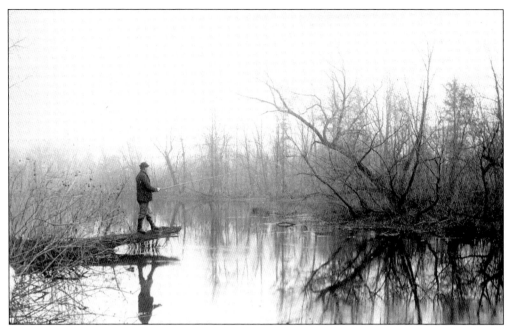

DELICATE CASTING SKILL. Buffington extends his reach into the backwater areas of a narrow stretch of water. The thick brush and fallen trees provided solid support, allowing fishermen to reach tight areas where fish would locate under brush. Tall boots kept the pants dry and warm during this late fall or early spring excursion. (Courtesy of the Momence Historical House.)

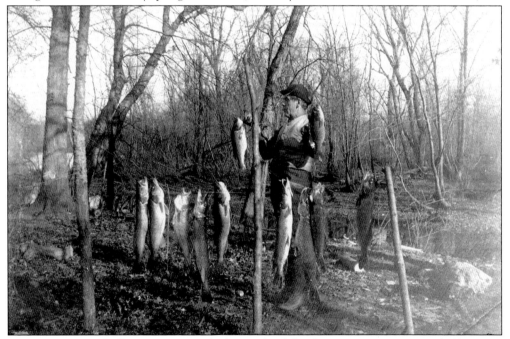

TODAY'S CATCH. Buffington poses with the catch of the day on a stringer suspended between small trees. The extent of thick brush in the area points to how well it served the camouflage needs of game residing in the area. The size and variety of fish illustrates the extent of significant fish in this gaming paradise. (Courtesy of the Momence Historical House.)

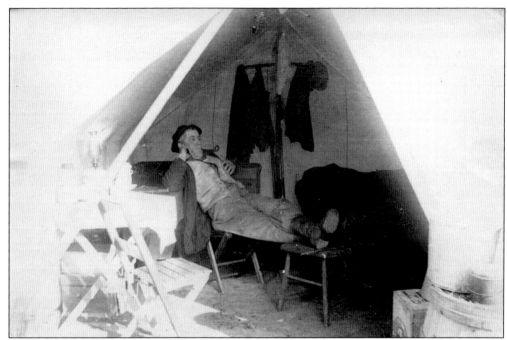

END OF THE DAY. LaFayette Buffington relaxes with his favorite pipe following a long day of fishing, trapping, and hunting. Furnishings even included a stuffed couch. The barrel on the right serves as a water catch for rainwater used to sustain the duo during their lengthy trips. Buffington rests his rifles on either side of the tent pole in the rear of the tent. (Courtesy of the Momence Historical House.)

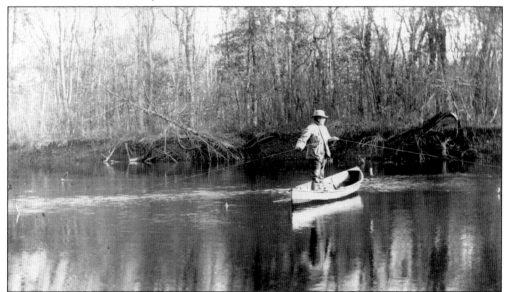

NIGHT LINE CHECK. Young kids who fish the Kankakee today learn early about laying in night lines in the slow-moving areas of the river. Here another fisherman checks his lines, which connect a series of bobbers fishing a bit more shallow in 1891. Numerous photographs show Buffington and Lane standing in their boat. This was common in flat-bottom boats used extensively in the area by locals. (Courtesy of the Momence Historical House.)

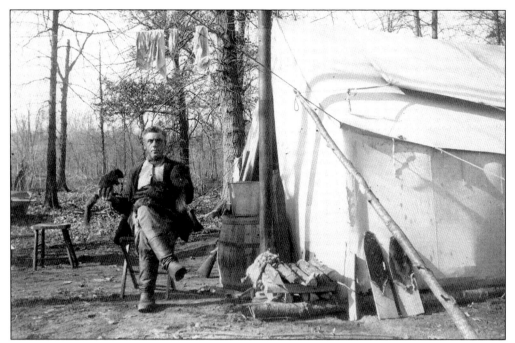

FEEDING FRIENDS. Showing the patience of a full-time outdoorsman, LaFayette Buffington holds a squirrel in the palm of his hand as another climbs up his arm in a search for food. Note the underclothes on the line, the water catch and smokestack, and the two small skins drying on wood planks leaning again the outside of the tent. (Courtesy of the Momence Historical House.)

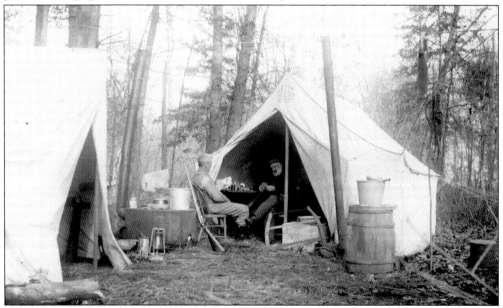

PASSING THE TIME. Buffington and Frank Lane take a break from outdoor activity playing cards inside their tent. Taken later in 1898, this photograph shows an older Lane and Buffington, perhaps unable to fish, hunt, and trap all day, falling back on this more casual activity. A close-up look of Buffington's cards shows an ace, three cards, and face card. Both men look rather gray at this time. (Courtesy of the Momence Historical House.)

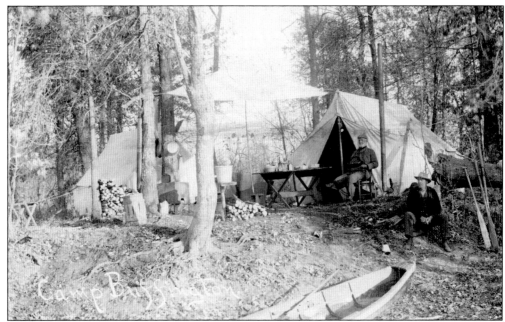

COMFORTS OF CAMP. An extensive camp is revealed in this photograph, near a significantly large fallen tree. LaFayette Buffington appears to have gained weight, and clearly Frank Lane has hired one of his photographers to take this rather posed shot. The river appears to be in the distance, and the interior of the boat reveals a rather flat bottom surface, allowing a man to stand and navigate in a gondola-style manner. (Courtesy of the Momence Historical House.)

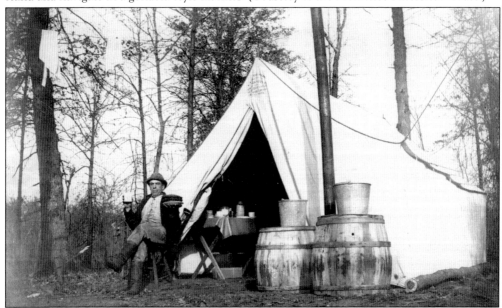

ALL THE TRIMMINGS. Surprisingly Buffington has made a cake in camp to go with his cup of coffee. Men who spent numerous days in the wild spent a significant amount of time cutting wood with a traditional saw. The extent of their rations and supplies suggests that Buffington and Lane spent a number of days in the field when they went on trips along the river. (Courtesy of the Momence Historical House.)

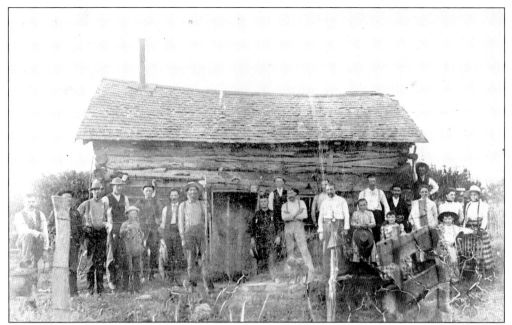

UNCLE DAN FANS. Likely conducting one of his many tours of the Garden of Eden, "Uncle" Dan Parmilee poses in front of his first cabins with visitors. The presence of women and children suggests that this was a formal tour conducted by Parmilee, who stands just to the left of the door with the full beard and hat. Parmilee became a little "touched" following a brawl in town where he hurt his head. (Courtesy of the Momence Historical House.)

DAN'S CABIN UPGRADE. Taken by Frank Lane, this photograph shows Uncle Dan's upgraded cabin. The presence of the fence in front of the wooden structure suggests it is in the same location as the original log cabin. He had nine children. His wife died in 1880, after which he lived with his children until his death. He is buried in Nichols Cemetery at Six-Mile Grove. (Courtesy of the Momence Historical House.)

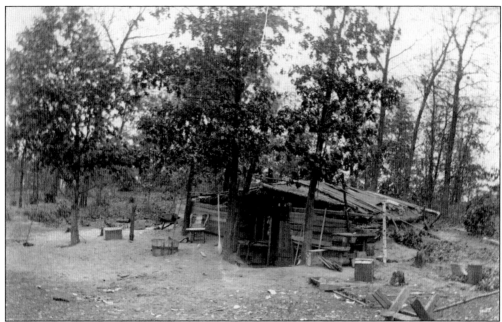

MINIMAL PROTECTION OUTDOORS. This photograph taken by Frank Lane shows how meager trappers and hunters lived in these full-time dwellings. Cleverly built into the side of a dirt mound, the design protected inhabitants from harsh wind. To the right of the entrance is a significantly sized iron stove, likely brought to the camp in a sizable boat. (Courtesy of the Momence Historical House.)

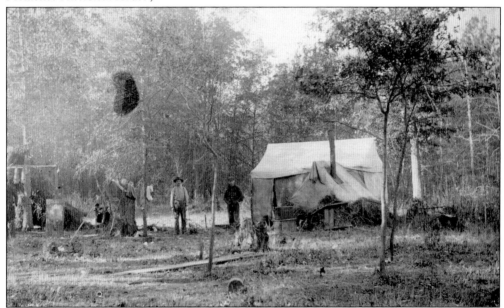

TRAPPER'S CAMP This significant photograph taken by Lane or his associate shows an extensive trapper's camp operated by professional campers who likely brought pelts to Momence for trading or a stiff drink. The area east of Momence was a trapper's paradise. A raccoon skin dries on a board to the left, and a significant heating or drying structure attaches to the trapper's tent. (Courtesy of the Momence Historical House.)

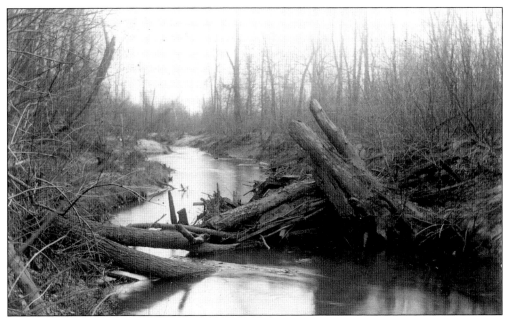

BACKWATER BOG REVEALED. This shot of nature taken by Lane shows how thick and dense the area of the Kankakee east of town was during the late 1800s. Waterfowl, beaver, and other small mammals were particularly fond of this environment, which provided a source of food and protection from predators. Dense woods created challenges for those willing live in the wilderness. (Courtesy of the Momence Historical House.)

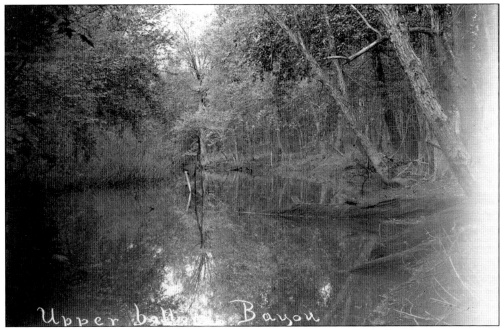

UPPER BAYOU. A bayoulike section of the Kankakee marsh demands shallow-bottom boats and skillful casting for fishermen. This photograph was likely taken from Lane's boat and shows his appreciation for nature's beauty. The area would have been more navigable by foot during the hard freeze months of winter. (Courtesy of the Momence Historical House.)

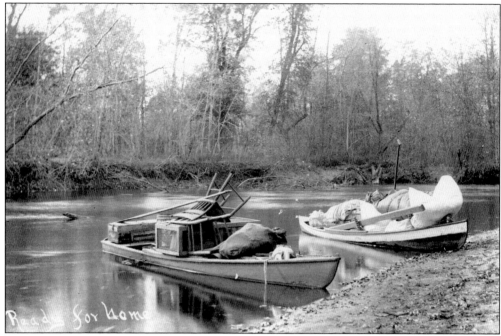

READY FOR HOME. It seems clear that a portion of the supplies may have been left behind or stored in the woods, as a full gear does not seem present in these two boats heading for home. Clearly the tent material and a favorite chair have been placed in the boat for the trip home. (Courtesy of the Momence Historical House.)

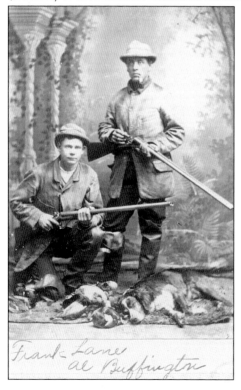

LIFETIME FRIENDS. The river was the joy of Frank Lane and LaFayette Buffington. This photograph was taken in Lane's studio. Buffington was born in 1850 and lived in Momence his entire life. He was the street commissioner in Momence for 25 years. He died in 1918 in a hospital in Chicago Heights after suffering a stroke three years earlier. (Courtesy of the Momence Historical House.)

Two
OLD BORDER TOWN

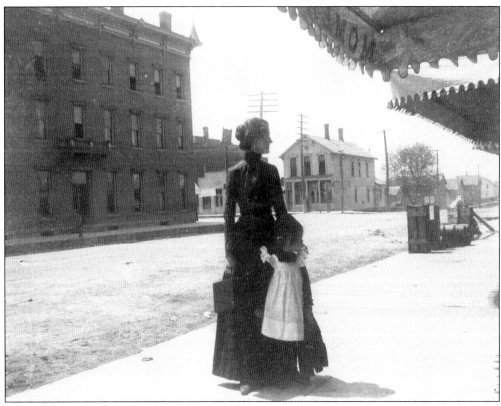

GIRLS GONE SHOPPING. Mother and daughter pause for one last look at merchandise, or perhaps a proprietor has called to them as they stroll east on Front Street across from Central House, which is now known as the Momence Hotel. The Parish Bank is not yet present in the distance. A young lad appears to be glancing at the two young ladies from across the street under the hotel balcony. (Courtesy of the Edward Chipman Library.)

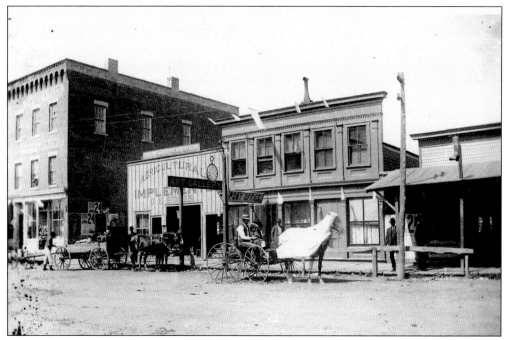

W. W. Parish Himself. W. W. Parish drives his horse and buggy up Range Street past the post office and a unique art gallery company with a pocket watch–styled clock designed for ornamental use only. His daughter Carrie Maria rides with him. Sadly, she died at age 23 from typhoid. Parish was a well-respected citizen of Momence and arrived in 1839 from Naples, New York. (Courtesy of the Edward Chipman Public Library.)

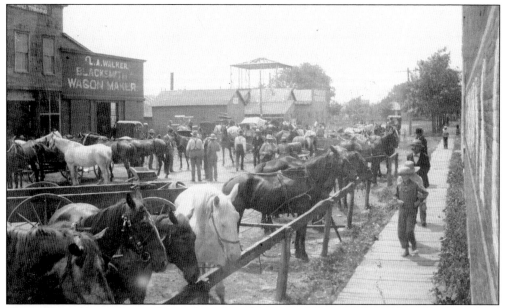

Horse Days. Showing an early penchant for celebrations, Momence hosts Horse Fair Days. Two young boys filled with excitement race barefoot on the wooden side down River Street toward Range Street, now Dixie Highway. The opened-roof structure in the back is the cider mill on the location where city hall currently stands. (Courtesy of the Edward Chipman Library.)

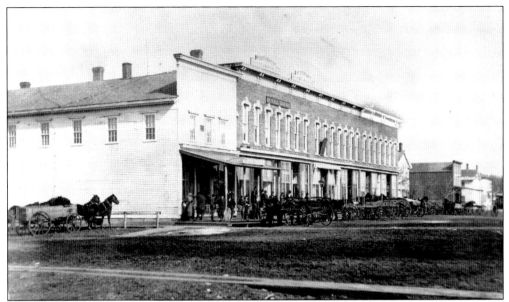

PROMINENT STRUCTURE. Built in the late 1800s, this building was a significant structure that housed Watson and Reins and Clapsaddle, the Momence Banking Company, Riker's Clothing Store, and Astle's Hardware. Astle's Hardware can still be experienced in its nearly original state and does some sporadic business when Chuck Astle arrives at the store. This photograph was originally taken on glass plate and was converted by Bruce O'Cull to photo paper. (Courtesy of the Edward Chipman Library.)

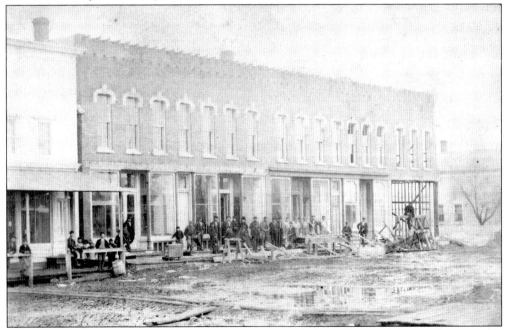

TEAM EFFORT. This extremely rare photograph of the Astle building shows workmen and a few boys posing in front of the incomplete building located on the north side of Front Street, now Washington Street. Notice how the exterior wall along the far right of the building is still incomplete, showing support timber for the brick facade. (Courtesy of Main Street Momence.)

CELEBRATION DAYS. Looking west on Front Street, now called Washington Street, this early photograph shows buildings decorated for an unknown community celebration. Based on the dirt street and other photographs in this collection, it may have celebrated the end of the Spanish American War or the fifth reunion of the 76th Regiment, Illinois Volunteer Infantry held in 1890. (Courtesy of the Edward Chipman Library.)

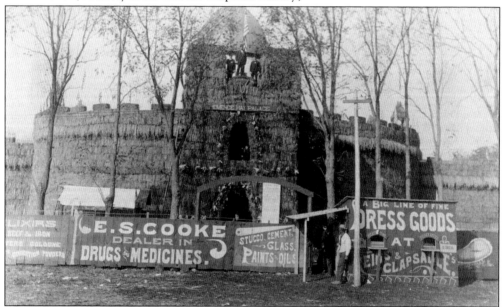

HAY PALACE. Showing the entrepreneurial flair unseen in most communities of its day, a group of businessmen in Momence raised $7,500 in 1890 to erect a Palace of Hay and hold an exhibit of products in the great hay-growing district of the area. Food tents, a merry-go-round, and game booths were staged on the outside over a four-block area. A second palace was built in 1891. (Courtesy of the Edward Chipman Library.)

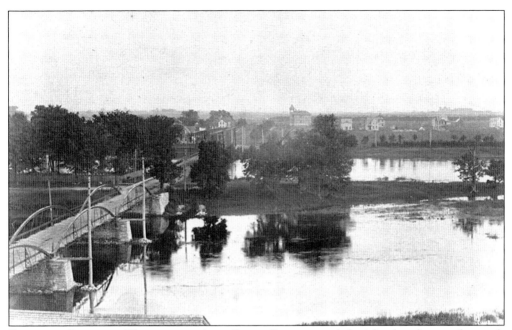

SOUTH TO LORAINE. This view south on Range Street toward the island and on to the south side shows Loraine School in clear view in the far distance. Very little development exists on the island or south of town. Note the fence structure on the island and both north and south bridge structures at the time. (Courtesy of the Edward Chipman Library.)

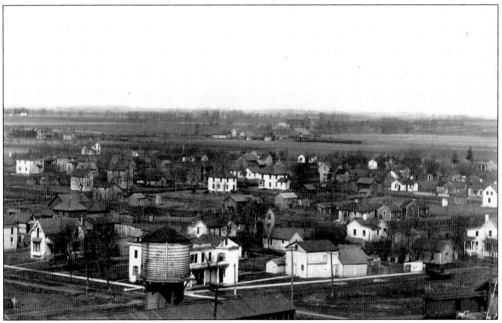

GRADUAL GROWTH. Taken from an elevated view in the 1800s, this photograph shows the spotty development of Momence at the time. Some of the larger homes are still present today. Archival notes indicate this photograph was taken looking northwest, which would indicate that the railcars in the distance are on the New York Central Railroad line. (Courtesy of the Edward Chipman Library.)

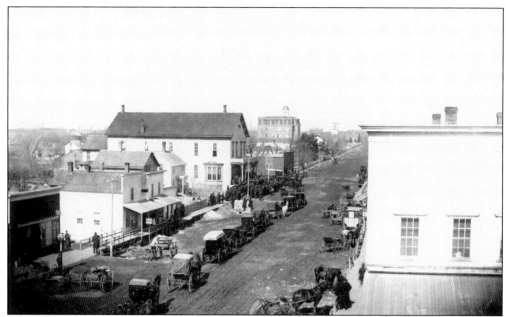

SADDEST OF DAYS. The double procession for Gus Meinzer, an engineer on the Danville-Chicago passenger run, and a fireman named Mr. Lowe processes to the Momence Opera House in the late 1800s. There was not a church large enough in Momence to hold the funeral, so it was held in the opera house. Every official from the Chicago and Eastern Illinois Railroad attended the service. (Courtesy of the Edward Chipman Library.)

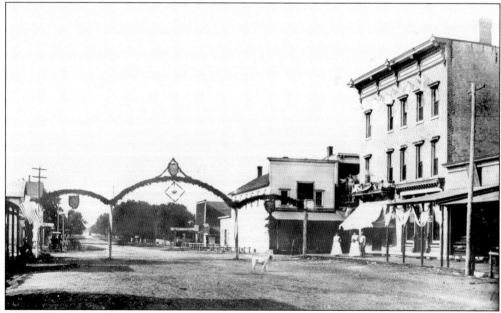

BOYS COMING HOME. Looking north on Range Street, which is now Dixie Highway, Momence prepares for a celebration marking the end of the Spanish American War. Oblivious to the impending event, a dog crosses Range Street just in front of the elaborate archway, which has been constructed across the entire street. A closer look at the hotel reveals an American flag mounted at every window on the hotel and along the rooftop. (Courtesy of the Edward Chipman Library.)

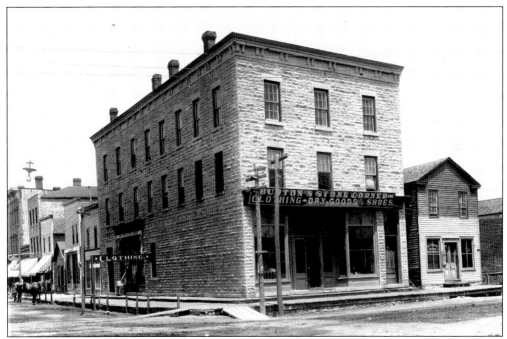

TODAY'S TEXACO CORNER. This stone structure, which housed a clothing and dry goods store, is at the corner of Range and River Streets, looking north. It was also home to the Merit Cap Factory operated by the Sandroff family. The theater was not yet built, and in the distance one can see the hotel, which was called Central House Hotel at the time. The building burned down in 1922. (Courtesy of the Edward Chipman Library.)

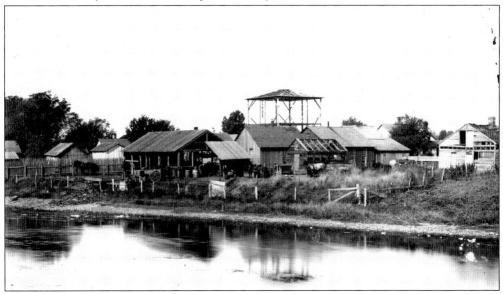

BROWN'S CIDER MILL. Taken from the north bridge looking northwest, this view shows the rear buildings along River Street in the late 1800s, including the cider mill operated by William James Brown, a notable inventor and businessman. He came to Chicago and then to Momence and built his home at the corner of Pine and West Second Streets. The mill was located where the current city hall stands today. (Courtesy of the Edward Chipman Library.)

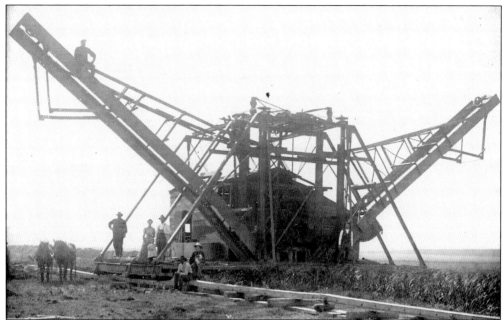

MAN'S BEAST. This rare photograph is of the machine used to dig channels and drain the Indiana side of the Kankakee River. The marsh was eventually drained, but an effort by Indiana to get Momence to remove limestone rock to deepen the river at Momence eventually failed. Note the young child and man with the dog and pipe posing in this shot. (Courtesy of Vic Johnson.)

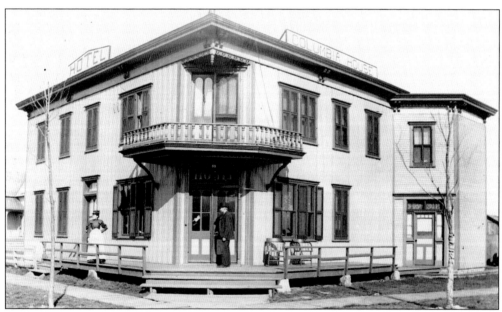

COLUMBIA HOUSE. The Columbia House was across from the Chicago, Danville and Vincennes Railroad. This was the first name of the Chicago and Eastern Illinois Railroad across from Orr Lumber. The hotel was commonly used by railroad men between runs. It was owned by a man named Drayer who provided meals that attracted local citizens on Sundays. It was built in the 1870s. (Courtesy of the Edward Chipman Library.)

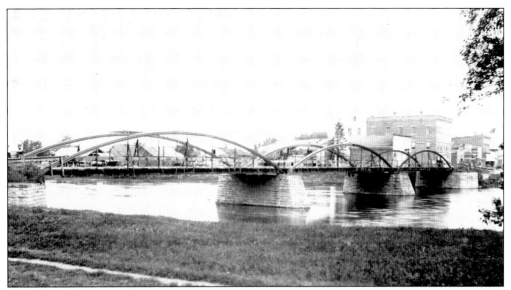

NORTH BRIDGE. Once referred to as a frog pond, the channel of the north branch of the river appears open and clear following construction of the north bridge. Downtown structures are visible beyond the bridge, and a close look at the photograph reveals a few young lads on the bridge looking to get in the picture on the far left. (Courtesy of the Edward Chipman Library.)

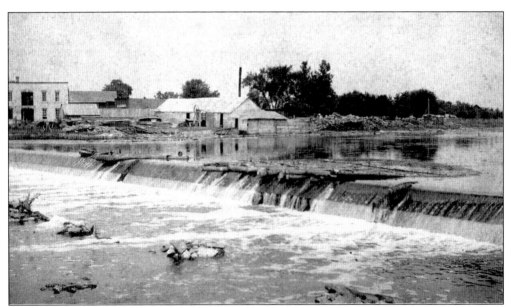

EARLY DAM. Furniture man John Deerson started his furniture business in 1854. This photograph shows the sawmill he constructed in support of his business. At the time, there was no railroad at Momence, so he brought finished product to the Illinois Central in Kankakee. The dam was upstream from the current dam in Momence and is no longer there. (Courtesy of the Edward Chipman Library.)

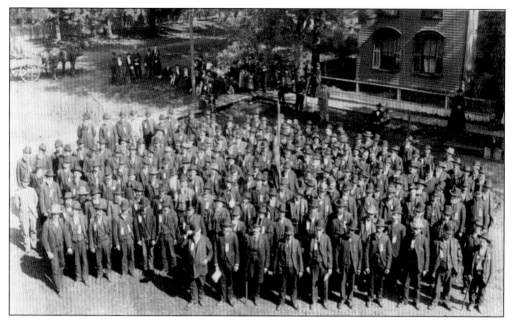

GATHERING HEROES. Members of the 76th Regiment, Illinois Volunteer Infantry gathered at Momence on October 2 and 3, 1890. This photograph was likely taken from the livery stable roof at the corner of Front and Locust Streets. Note the brass band in the rear of the photograph. (Courtesy of the Edward Chipman Library.)

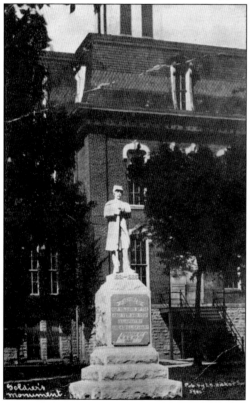

LIFETIME TRIBUTE. This familiar statue in Momence is a tribute to the men of the 42nd, 76th, and 113th Illinois Infantry and the 4th Illinois Cavalry made up of Momence men during the Civil War. It was erected in 1909. The Women's Relief Corp, organized during the Civil War to provide nursing supplies and clothing to the troops, raised the money for the statue. Illinois governor Charles Deneen dedicated the statue on July 5, 1909. (Courtesy of the Edward Chipman Library.)

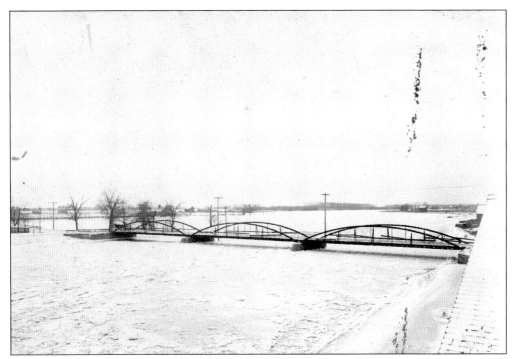

FROZEN BRIDGE. River levels run high as a deep freeze settles in Momence. This is the north bridge connecting the island to downtown. The view is looking southwest. The diminutive nature of the west end of the island is notable compared to today. There are just a few structures on the far side of the river where commercial business is now located. The north side of the riverbank reveals far fewer homes than today as well. (Courtesy of the Edward Chipman Library.)

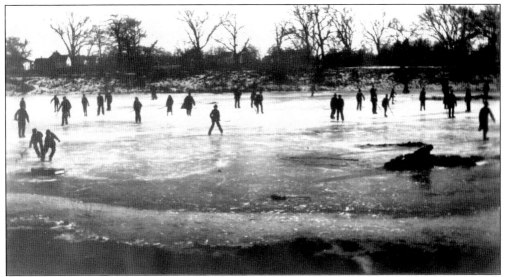

SKATING ON THE RIVER. This rare photograph shows Momence locals enjoying the frozen Kankakee River. It is unclear where the shot was taken, but it is near town due to the presence of homes in the distance. At least two hockey games are in play. Just as is the case today, logs and other brush often jut out of the ice surface due to the nature of the river, requiring skaters to stay clear of nature's obstacles. (Courtesy of the Edward Chipman Library.)

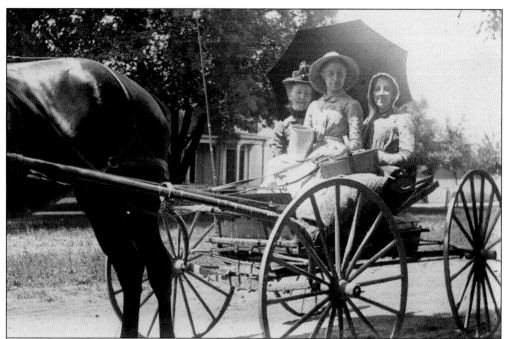

BUGGY RIDE HOME. Three young ladies return from picking berries during a warm day in summer. This common mode of transportation was used to go far distances. Note the varied headdress of all three women and the umbrella to protect them from the hot sun or rain. This photograph was taken in Momence in the 1800s. (Courtesy of the Edward Chipman Library.)

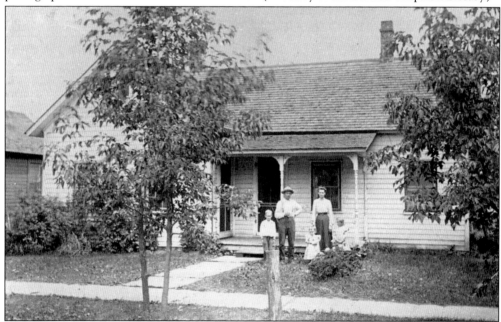

THE JENSEN HOME. Charlie and Christine Jensen lived at 48 Market Street for 68 years. The Jensens regularly sponsored other Danes who wished to come to Momence, often housing boarders in this small house. The home has been expanded and is occupied currently by Marilyn "Mal" Jensen Peterson. (Courtesy of Marilyn Peterson.)

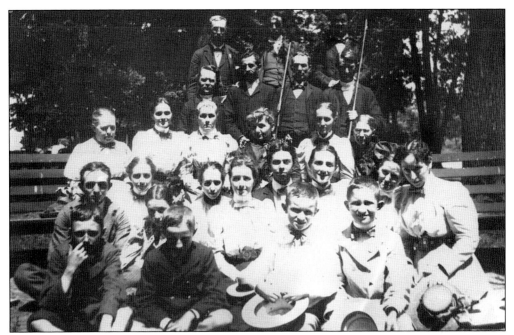

ISAAC WALTON LEAGUE. Common in many communities today, the Isaac Walton League works to preserve parks and natural areas. This group of young people is the local chapter of Isaac Walton taken in the late 1800s. The Momence area had plenty of nature to preserve at the time, and the club likely served as a good social outlet for these members as well. (Courtesy of the Edward Chipman Library.)

FRIENDS ON THE BRIDGE. These two friends pose on one of Momence's bridges during a summer outing around the beginning of the 20th century. It appears to be the south bridge due to the steel construction. Note the kerchief carried by each woman. Their identity is unknown. Beyond the bridge one can see the shallow nature of the river at this point. (Courtesy of the Edward Chipman Library.)

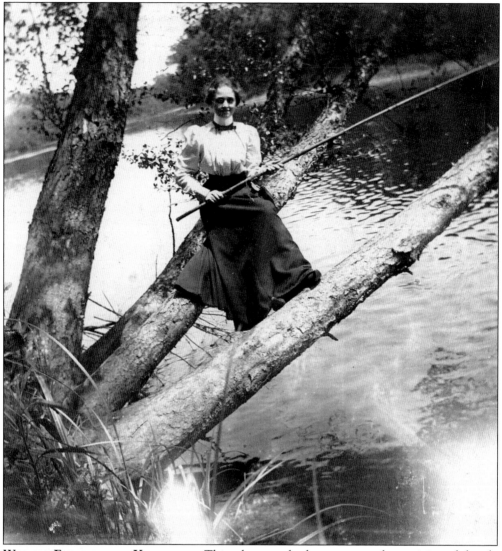

WOMAN FISHING THE KANKAKEE. This photograph demonstrates the activity of female residents of Momence and the unique wardrobe used to go fishing. This posed shot shows an interesting manipulation of the landscape as the horizon line in the rear is tipped, indicating that the subject is leaning much farther to the right than is apparent. (Courtesy of the Edward Chipman Library.)

Three
A WORLD OF CHANGE

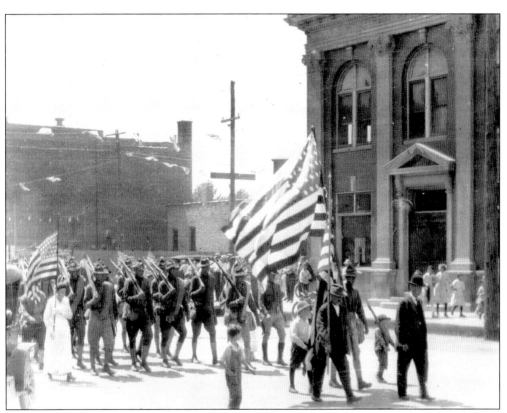

OFF TO WAR. The nature of this parade of doughboys up Range Street suggests that they are going off to war rather than coming home, but it is difficult to tell. Every town in America would be altered as a result of World War I. Women and children join the march, and a man watches them pass from the window in the bank building. (Courtesy of Main Street Momence.)

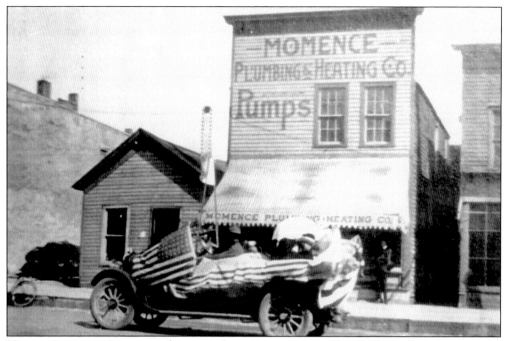

VICTORY'S PRIDE. A motorist drives south on Range Street either at the end of the war or in celebration of the Fourth of July. One of the most famous World War I veterans was Pat O'Brien, who was born and raised in Momence but flew for the Royal Flying Corp in Canada. He fought the Huns and was taken as a prisoner but escaped to come home again. (Courtesy of the Edward Chipman Library.)

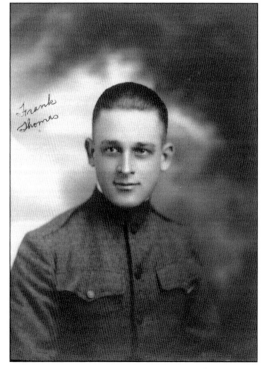

FRANK THOMAS. This photograph was found among many of the World War I men from Momence who fought the Great War. Many men did not return. The long history of veterans back to the Civil War has made Momence a particularly patriotic community to this day. Local citizen Bill Munyon features many war veteran photographs in the depot museum on the north end of Dixie Highway. Veterans' organizations have played a vital role in Momence for years. (Courtesy of the Momence Historical House.)

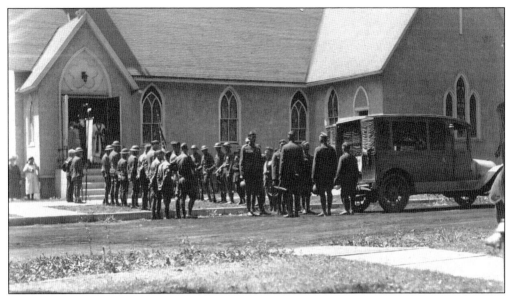

FALLEN HERO. A World War I honor guard attends to the casket of a fallen comrade at the Episcopal Church of the Good Shepherd. Off to the side are ladies in mourning as the honor guard and pallbearers prepare to bring the casket into the church. Note the flag draped casket inside the hearse. (Courtesy of the Edward Chipman Library.)

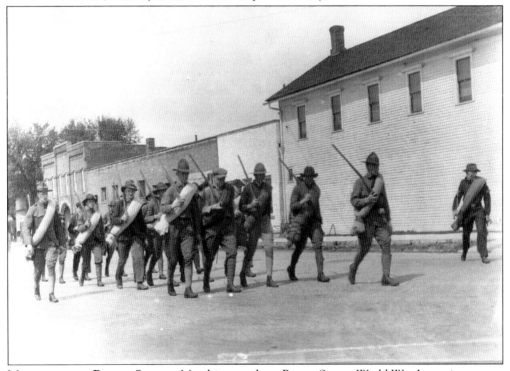

MUSTERING UP RANGE STREET. Marching south up Range Street, World War I recruits prepare to muster toward their latest assignment complete with their bedrolls swung over their left shoulders. Note some are still in civilian clothes. The buildings in the background are still present today. The livery stable is at the end of the block. (Courtesy of the Edward Chipman Library.)

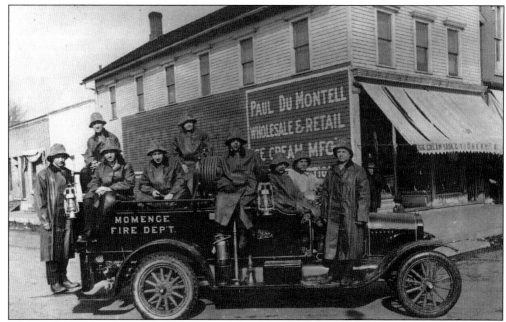

CITY'S SAFETY. The Momence Fire Department has a long history of support in the community. This volunteer department has been active for a number of years. Volunteers pose with their latest equipment at the corner of Range and Front Streets. Notice the advertising for Paul Du Montell on the side of the corner building. A young lad peers over the hood of the truck. (Courtesy of the Momence Fire Department.)

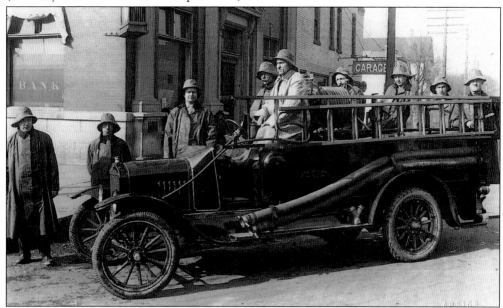

MODERN UPGRADE. This wonderful photograph shows the same truck as the one above but taken years later on the opposite corner in front of the bank. The exterior clock, which was on the bank corner until recent years, can be seen as well as the automobile garage to the north. Reising Ford occupied this space and another space across the street in later years. Again a small child peers through standing on the steps of the bank. (Courtesy of Jim LaMotte.)

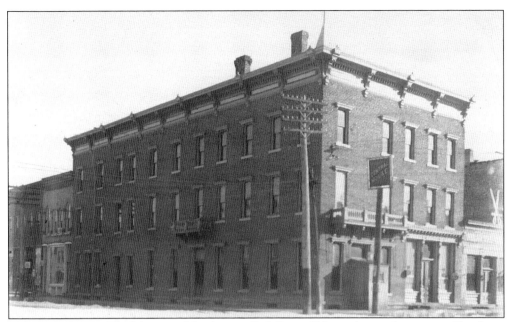

CENTRAL HOUSE. The Momence Hotel was called Central House during this time and has been a landmark in the community for a number of years This photograph shows the early design of the building, including balconies on the north and west facade and the simple entrance with a wind block addition designed to keep the cold and likely the dust from entering the hotel. (Courtesy of the author.)

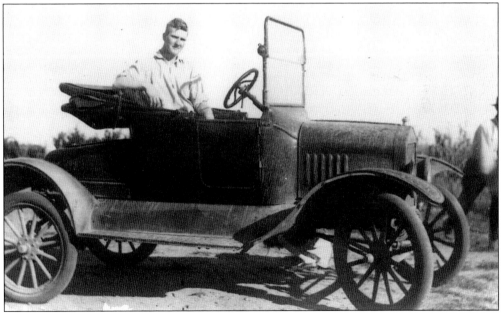

MECHANICALLY READY. The father of local historian and Momence native Bill Munyon takes a spin in his new car. Munyon's dad was one of many young men more than eager to make use of the automobile following the war. He is an active member of the community today and, among many other things, is know for his depot museum and unique silo at home that features a real tractor on the roof. (Courtesy of Bill Munyon.)

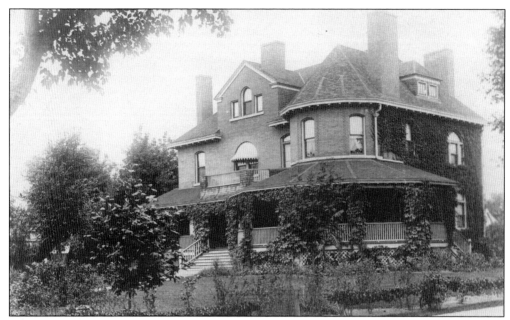

WIKSTROM HOUSE. This early photograph of the famous Momence landmark shows the house owned by Axel Wikstrom, who came to America in 1865. He was an avid hunter and fisherman, but he did not live long in the house due to his death. His farmhouse was north of St. George Road and west of Dixie Highway. Rumors persisted that he was a member of Swedish royalty before coming to Momence. The house is still in Momence. (Courtesy of the Momence Historical House.)

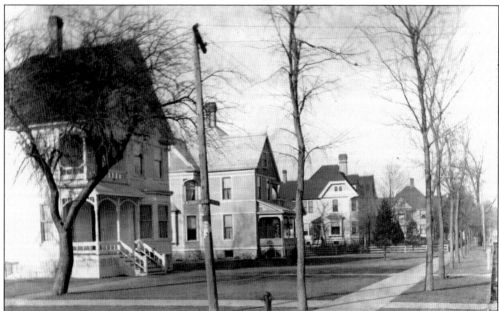

GRAND MOMENCE HOMES. These 19th-century homes still exist in Momence today. These homes are at the corner of Front and Maple Streets. Front Street is now Washington Street. Note the street signs and billboards attached to the street pole. Many of these old homes still maintain the hitching posts, seen on the far right, although horses are long gone from the community. (Courtesy of the Edward Chipman Library.)

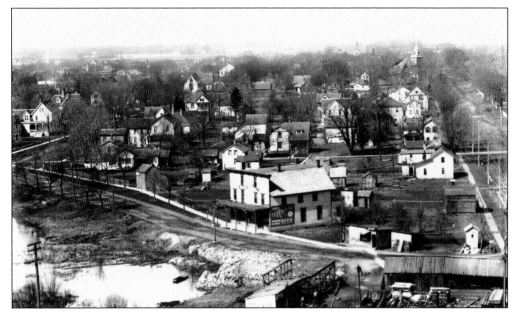

LOOKING WEST. This striking view is taken from the east looking west across town. The Baptist church steeple is present along with the rooftop of St. Patrick's Academy, which places this photograph in the 20th century. Note the store in the foreground advertising F. D. Radeke Beer. Radeke beer was brewed in Kankakee. (Courtesy of the Edward Chipman Library.)

NEIGHBORHOOD DEVELOPMENT. Signs of a postwar, growing community are demonstrated in this fully developed neighborhood where all lots have homes and maturing trees. A man with a period-style hat walks briskly down the wooden sidewalk, another sign that neighborhoods are becoming fully developed. Suspended electrical lines also dominate the landscape. (Courtesy of the Edward Chipman Library.)

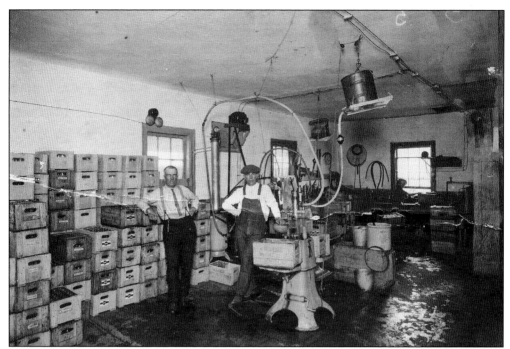

BUSINESS PIONEERS. This early photograph shows the interior of the Momence Bottling Company. The original name of the company was Island Park Bottling, started by Arden Sherwood on the left. His son Claude is on the right. It was later sold to Coca-Cola as Orange Kist Bottling Works. Momence had a number of locally owned businesses that provided jobs and economic stability to the community following the war. (Courtesy of Kathy Sherwood Sievers.)

FRONT STREET EAST. A small automobile turns east on Front Street at the location one block from where the current post office stands today. Dirt roads still persisted during the early days of the iron horse. Note the home owner cutting his lawn with an old push mower on the left. In the far distance is the merge with the east end of River Street. (Courtesy of the author.)

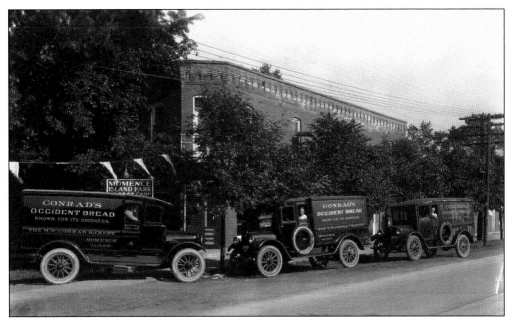

CONRAD CARAVAN. Oscar Conrad started the bakery, which was also a hotel, and his son Henry took over the business following World War I. After the death of Mr. and Mrs. Henry Conrad in a car accident, the Litoborskis ran the business. When members of the Chicago outfit kidnapped Henry in 1929, Charles McNulty, grandfather of the author, was ordered to drive the truck at gunpoint. He is pictured in the third truck on the right. (Courtesy of the Edward Chipman Library.)

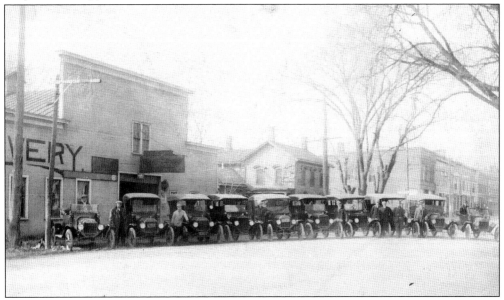

HORSELESS CARRIAGE. The livery stable on east Front Street converted to an early Ford dealership that lasted in Momence for some years. Operators line up the latest models on the street for a publicity photograph. Front or Washington Street can be seen beyond the row of cars. The commercial buildings west of the livery today are not yet present. Momence had many automotive dealers in town by the early 1960s. (Courtesy of the Edward Chipman Library.)

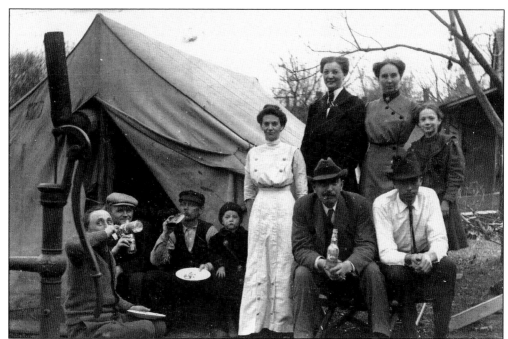

BOARDING ROOM. Boarders from Sweden find temporary quarters in the backyard of Charlie Jensen. The Jensens first lived above the Wennerholm Garage and Livery until they moved into their home on Market Street. They were active in bringing other Danes to the new country, a common practice among immigrants in America. (Courtesy of Marilyn Jensen Peterson.)

FAMILY TIES. The Munyon family poses outside their Momence home. Local historian Bill Munyon indicates that there was one family member that could not join them outside but watched out the window. Generations of Momence families stayed in Momence in these days. Today small-town kids tend to move elsewhere, driven by the job market in American cities and the ability to rapidly fly home for regular visits. (Courtesy of Bill Munyon.)

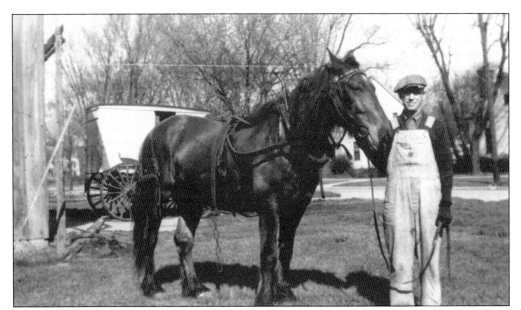

DAIRY TEAM, 1941. Walter Graefnitz readies his horse for the morning delivery of dairy products for the Momence Dairy. Despite the increased use of automobiles after World War I, horsepower was still employed for various tasks on the farm and in the cities. As World War II rationing was about to occur at this time, Graefnitz likely values the use of his horse in the 1940s. (Courtesy of Vicki Carpenter Sommer.)

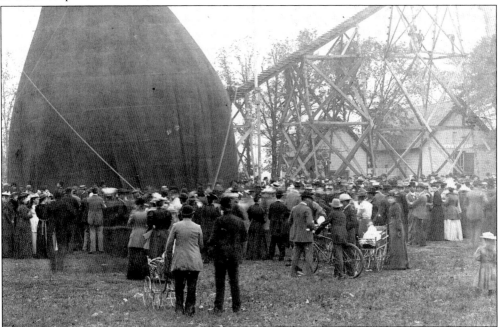

ISLAND MIDWAY. This balloon is about to go up at the Island Park at the beginning of the 20th century. Special trains brought such amusements from the city for a day. The roller coaster slide was constructed on site. The balloon was filled with gas from a small fire built underneath. The pilot swung from a swing and jumped with a parachute when the balloon reached a significant height. (Courtesy of the Edward Chipman Library.)

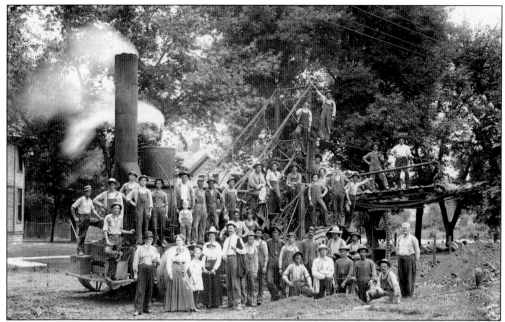

CITY SEWERS DEVELOPED. Workers install modern sewers on Locust Street. Sewers were installed during 1909 and 1910. Momence blacksmith Joe LaPlante appears on the far right in this photograph, seemingly in a supervisory role. Momence began a period of modernization following 1900 that improved the quality of life for all residents. (Courtesy of the Edward Chipman Library.)

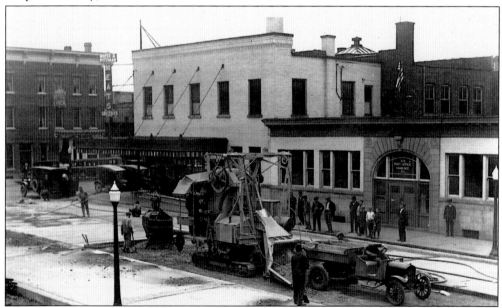

PAVING WASHINGTON STREET. Another sign of modern times shows workmen paving Washington Street in front of the post office. This photograph also reveals the installation of the classic Washington Street lamps. In the mean time, product is being unloaded for the grocery store and one can see a bus parked in front of the hotel, which now features a restaurant for lunch. (Courtesy of the Edward Chipman Library.)

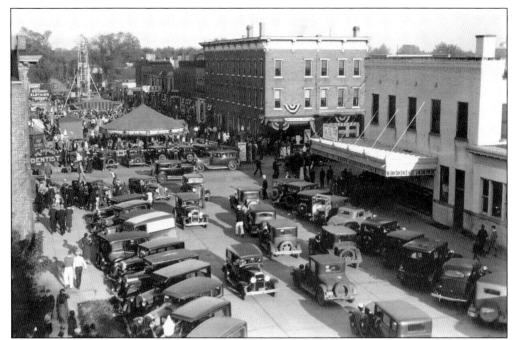

CENTURY OF PRIDE. Momence pauses to celebrate its centennial in 1934. The newly paved streets provide ample parking for everyone attending the midway located east of Dixie Highway. Note the stop-and-go light on Dixie Highway and numerous signs indicating businesses in town. The hotel signage now indicates it is the Momence Hotel. (Courtesy of the Edward Chipman Library.)

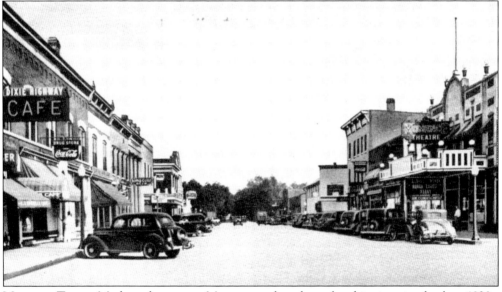

MODERN TIMES. Modern downtown Momence takes shape by this time in the late 1930s, showing many of the establishments that were present through the 1970s. Note the Momence Theatre marquee design in its original format. While the movie playing that day is not visible, a close-up of the marquee reveals air-conditioning as a feature of the new theater. (Courtesy of the author.)

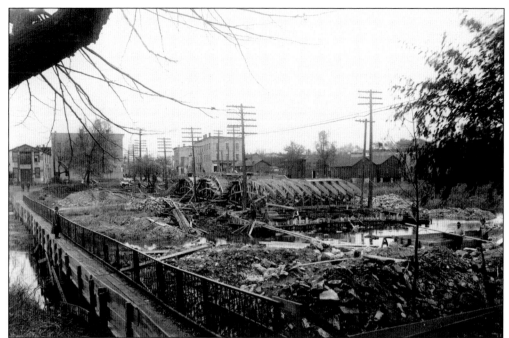

FROG POND CROSSING. In one of the more mysterious photographs found, this unusual and rare photograph shows the construction of the north concrete bridge. The river was full of silt and shallow to the point that it was referred to as a frog pond. Workers construct the forms that will shape the concrete pillars of the bridge. The view is looking north from the island. (Courtesy of the Edward Chipman Library.)

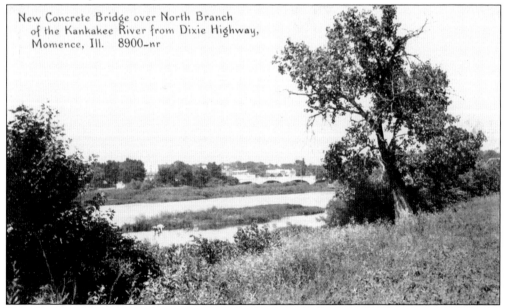

NEW BRIDGE COMPLETED. In another unique photograph, the completed concrete bridge over the north branch of the river can be seen in the distance. The photograph was taken along the south bank of the river looking northeast along Route 1 and 17. Note the person wading in the river in the foreground. (Courtesy of the author.)

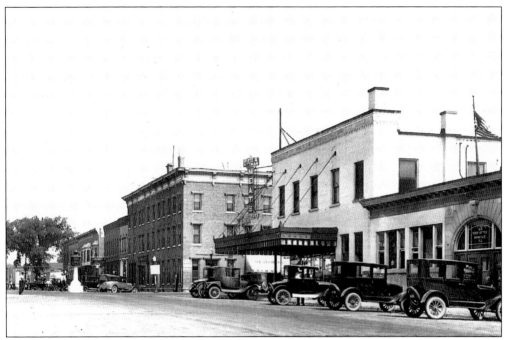

STOP-AND-GO LIGHT. The use of automobiles in the early 1920s required a traffic light at the intersection of Washington Street and Dixie Highway. The national highway was constructed between 1915 and 1927 from Chicago to Florida. Following the path of Hubbard's trail, it passed through Momence, ensuring continued commerce through the community. (Courtesy of the Edward Chipman Library.)

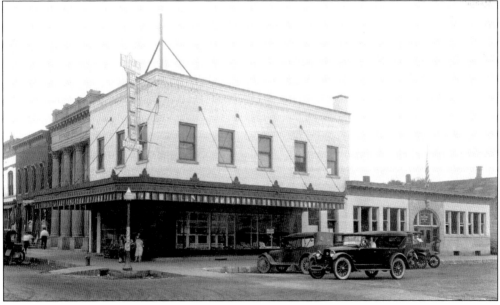

CITY CENTER. This shot of Reitz and Pittman Groceries with the post office to the right and Parish Bank to the left was taken in the 1920s. It shows the full use of the automobile at that time but was taken before the concrete streets were poured. Concrete walks extend from curb to curb for pedestrians. (Courtesy of the Edward Chipman Library.)

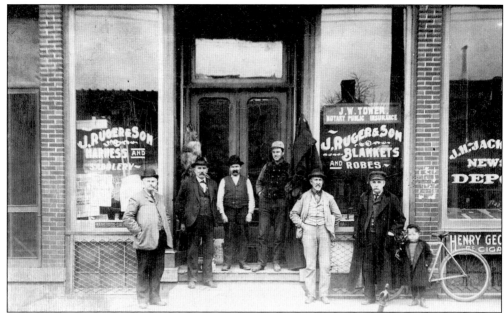

PROPRIETOR'S PRIDE. J. Rugger's fine harness shop operated on Front Street when there was still a need for equestrian products. Not all the men are known in this photograph, but Joseph Tower is believed to be the second man from the left, and the man in the middle is Peter Bydalek. At the far right are Dick Smith and his son. The man in the cap in the step may be Fred Clark, according to local historians. (Courtesy of the Edward Chipman Library.)

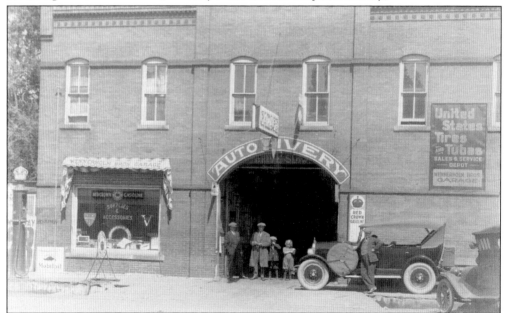

WENERHOLM LIVERY. Like many livery stables making the transition, Wennerholm operated the livery as a garage as well until services for horses were no longer needed. Owner Gus Wennerholm was born in Sweden in 1870 and came to America in 1886. Numerous immigrant Danes lived temporarily upstairs in this building before establishing their own homes in town. (Courtesy of the Edward Chipman Library.)

PARISH BANK. This early photograph of the Parish State Bank, later called the Parish Bank and Trust Company, shows the absence of a structure to its right. A closer look reveals a Momence native resting on a downtown bench made of lumber and two barrels. W. W. Parish Jr. established the bank, and the Parish name has been prominent in Momence since its beginning. (Courtesy of Velma Henniger.)

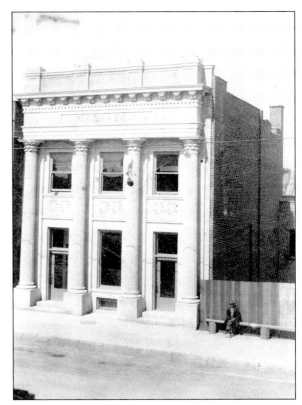

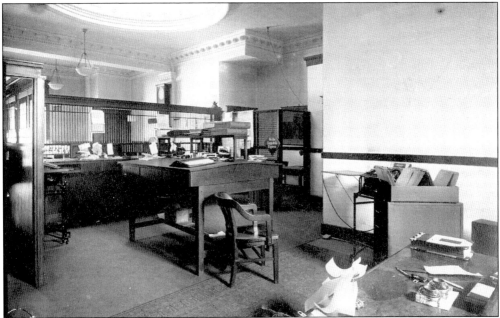

INTERIOR OF PARISH BANK. This rare photograph was taken early in the establishment of the Parish Bank. It shows the everyday tools of modern banking at that time. The prominent dome in the ceiling is clearly visible. Years later the bank moved to Washington Street and was later sold and acquired another name. (Courtesy of Velma Henniger.)

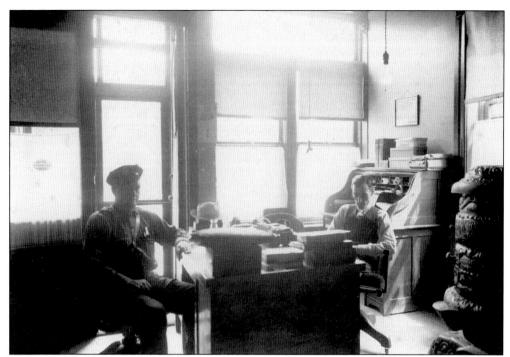

MOMENCE SECURITY. Pat Barker, at one time the only policeman in Momence, sits with Edward Gilbert, police magistrate, in his office, which is now the Momence Township office on River Street. Barker was well known and a classic small-town cop who knew everyone, and everyone new him. A potbelly stove heats the front office. (Courtesy of Betty Gilbert Dionne.)

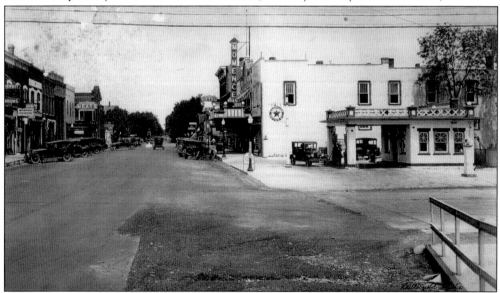

MOMENCE, 1930. This photograph demonstrates how complete modern-day Momence was by 1930. There was a lot of development in town after World War I. The community would soon face the Great Depression. The Texaco gas station and Momence Theatre are clearly present on the right. The hotel has acquired yet another name, the Madsen Hotel. (Courtesy of the Edward Chipman Library.)

Four

MODERN MOMENCE

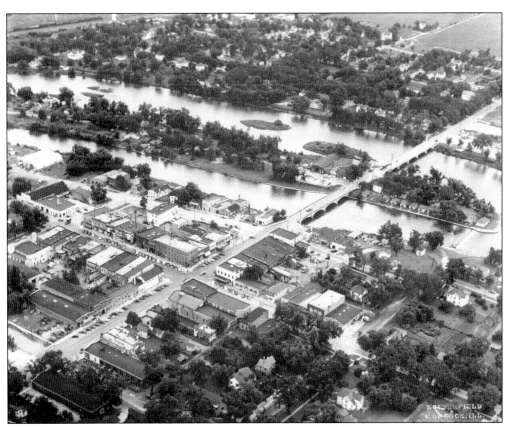

MODERN MOMENCE. This overhead shot reveals post–World War II Momence at its peak. The baby boom era and economically robust times following the war created one of the best times for the city. Nearly every storefront was active, and new neighborhoods were being developed for returning GIs. It was a great time for American cities after the war. (Courtesy of Sue Butterfield.)

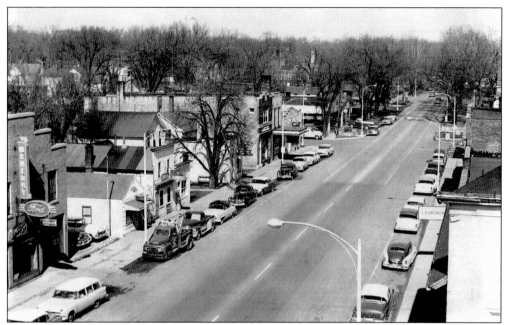

DIXIE HIGHWAY, 1950S. This photograph was taken from the roof of the hotel looking north on Dixie Highway in the 1950s. Clearly visible in the distance is the hall at the Methodist church, Therien's Chevy dealership, and Reising's Ford Mercury Dealership. Gene's Lunch on the west side of Dixie Highway did a robust business and can be seen in the middle of the block on the left. (Courtesy of the Edward Chipman Library.)

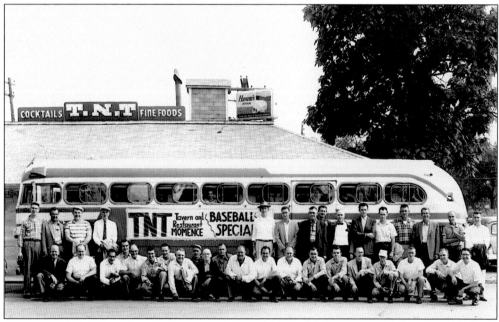

THE "T," 1959. The Chicago White Sox won the pennant in 1959, and this familiar group of baseball fans is preparing for their bus ride to Comisky Park. The men's outing was sponsored by the TNT, which was owned by Jack and Bill Cromwell. They are pictured on both ends of this large group of fans. (Courtesy of Betty Gilbert Dionne.)

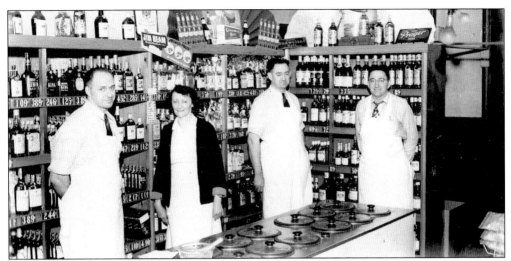

GROCERY ICONS. Every person that lived in Momence from the 1930s to the 1970s would recognize this photograph of the Mullady family in Mullady's Grocery Store. They had a full line of goods including alcohol and ice cream, as demonstrated in this photograph. Pictured from left to right are Frank, Margaret "Mig," Ray, and John Mullady. (Courtesy of Mary Mullady Cantwell.)

FAYE ORR. Longtime resident and businessman Fay Orr had was active in the community and a supporter of a number of efforts in town. He owned and operated his lumber and grain elevator business along the tracks of the Chicago and Eastern Illinois Railway. He also served on the school board. His company is still operating in Momence, although he has since passed away. (Courtesy of the Progress Reporter.)

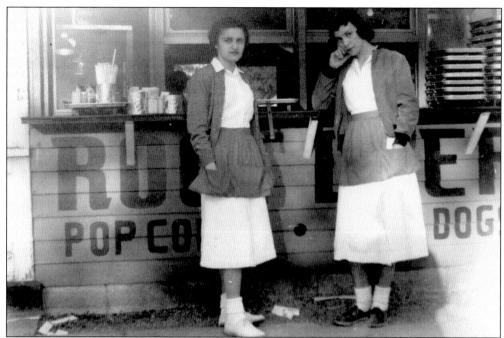

TOOT 'N TELL US, 1956. Stetson's Toot 'n Tell Us was a classic 1950s drive-in, complete with car hops, root beer, and hot dogs. Pictured in their carhop uniforms are Kay Fite Laue (right) and Pat LeMontaque. Stetson's later became Dionne's located north on Dixie Highway. This serving area faced south. Serving trays that hung on the driver's side window are stacked on the right. (Courtesy of Kay Fite Laue.)

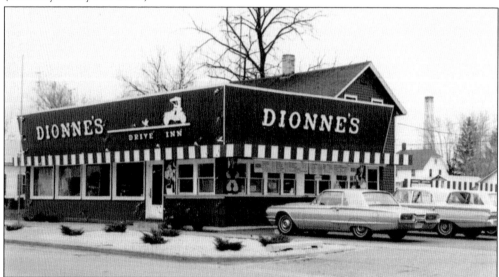

DIONNE'S DRIVE-IN. Skip and Gene Dionne purchased Stetson's in 1963 and continued the drive-up menu for a number of years before converting the shop to the French Country Café in 1980. Dionne's employed numerous teenagers from Momence and was a favorite hangout for young people through the 1960s. Demonstrating yet another example of Momence's flare for style, they created a whole new look to the building each time the menu changed. (Courtesy of Betty Dionne.)

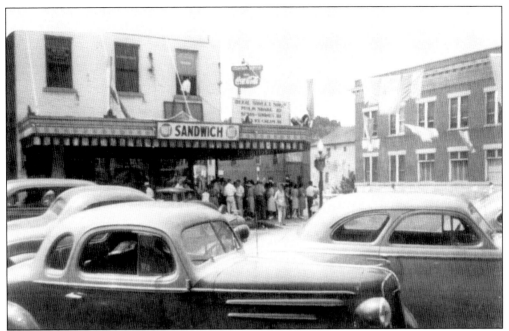

DIXIE SWEET SHOP. The corner of Dixie Highway and Washington Street featured a favorite spot for ice cream in the 1940s. Here patrons gather under the convenient canopy during the Gladiolas Festival as evidenced by the banners hung above the street. The building was later torn down. Rural patrons in the late 1930s and 1940s drove to town to by groceries at this store and buy ice cream on a hot summer evening. (Courtesy of Sue Butterfield.)

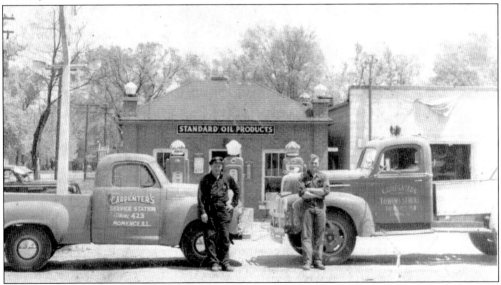

CARPENTER'S STATION. Robert Carpenter, standing in front of the pick-up truck, and DeWitt Carpenter, in front of the tow truck, operated the Standard Oil station on the north end of Dixie Highway. This photograph was taken in the early 1950s. Their station was directly south of Stetson's, and the building still stands. Phone numbers in Momence at the time were three-digit numbers, as is evident on the trucks. Later the prefix "Gridley" or "GR" was used ahead of five digits. (Courtesy of Vicki Carpenter Sommer.)

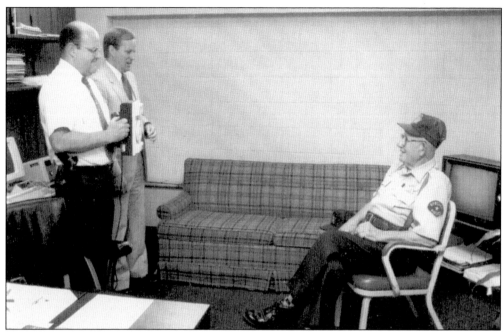

BIG BILL. Bill Grant was an iconic figure in Momence for nearly 30 years. Anyone that attended school in Momence during his time will recall his years of crossing guard duty. He was an avid Gladiolas Festival fan, and in his later years, the festival committee made him grand marshal of the parade. It was the biggest thrill of his life. Grant is seated on the right and receives instructions for the day. (Courtesy of Momence Progress Reporter.)

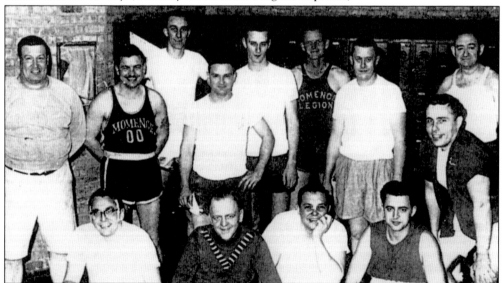

PICK-UP GAME. Many people will recognize faces in this group as some of the leading businessmen in town during the 1960s enjoying a game of basketball in the Momence Gym. Those recognizable include Jim Speith, Chuck Astle, Frank Simpson, and Dick LaMotte in the first row. Bob Broulette is standing second from right, Gene Therien is third from left behind Astle, Ray Mullady is in the back on the far right, and Les DuMontelle is posing in front of Mullady. (Courtesy of Jim LaMotte.)

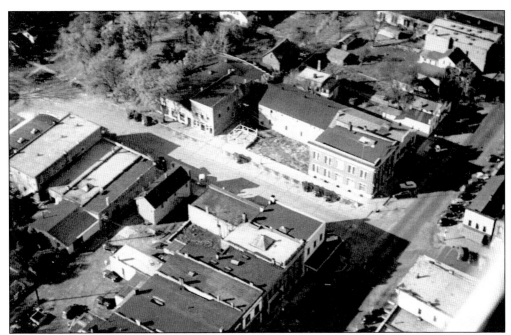

CROSSROAD, 1940S. This aerial view of Momence is taken at the intersection of Dixie Highway and Washington Street. Based on a close-up view of the automobiles, it appears to have been taken in the 1940s. Most notable about the photograph is the structure missing behind the bank building and across the street on Washington Street. There are also a number of trees no longer present on the northeast corner of Washington and Pine Streets. (Courtesy of Sue Butterfield.)

MOMENCE LAUNDRY. This nondescript building may be difficult to recall, but it was the home of the Momence Laundry located on River Street. The laundry was directly across the street from Mullady's Store and backed up to the north branch of the river. The laundry functioned well into the 1960s but is no longer in business. (Courtesy of Mary Mullady Cantwell.)

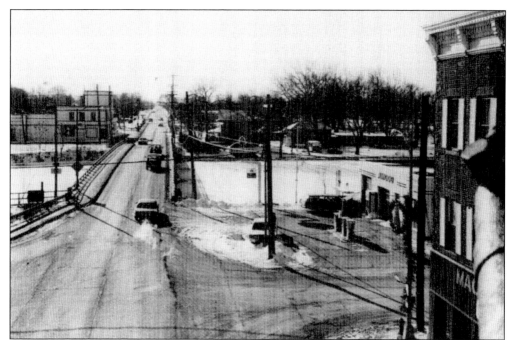

SOUTH ON DIXIE HIGHWAY. This unique photograph was likely taken while repairing lighting or cables hung over Dixie Highway. The large bolt and piping on the right of the photograph indicates that the photographer is working from a crane, perhaps putting up or removing Christmas decorations. The photograph was taken in the late 1960s or early 1970s and shows a remodeled Conrad's Bakery building on the island and the Standard gas station, which is no longer there, on the right. (Courtesy of the Progress Reporter.)

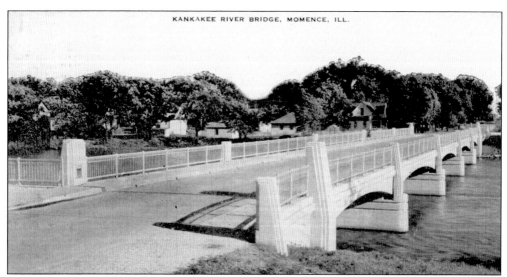

SOUTH BRIDGE. The concrete bridge on the south branch of the river replaced the old steel bridge that connected the south side to the island. This heavily traveled road bridge carried extensive traffic from Dixie Highway, requiring strong engineering design. For over 200 years, bridging the Kankakee River was critical to commerce in the frontier and during modern times. (Courtesy of the author.)

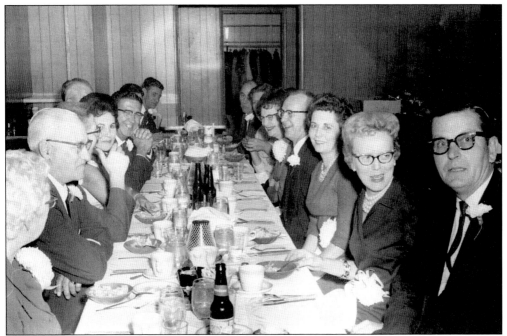

LOCAL CELEBRATION, 1960s. Some Momence notables gather for what appears to be an anniversary or birthday party. Front right includes Paul and Pauline Thyfault, Dorothy and Fred Jensen, Cora "Peg" Baechler, and Rose and Armand Mazzacoo. The left side is believed to be Fran Cromwell followed by Bob LaMotte and toward the end is Tibie and Jack Crowell. Numerous locals attempted to identify the group. (Courtesy of Marilyn Jensen Peterson.)

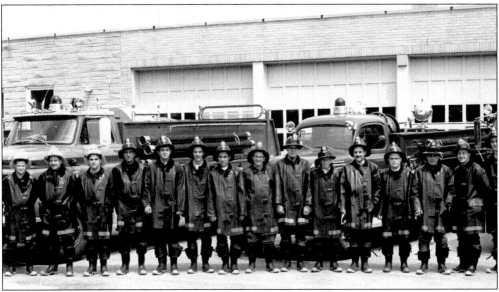

MODERN FIREFIGHTERS. The height of the department in the 1960s shows how much progress was made from the fire department's earliest beginnings. Volunteer firemen pose in front of the new firehouse. Today a new location exists across the street from this facility. A number of current and retired firefighters can be seen in this photograph in their younger days. (Courtesy of the Momence Fire Department.)

MOMENCE THEATRE. The Momence Theatre extended its life into the 1970s before finally closing down. A single patron stands in front of the entrance. Today there are efforts by the Momence Theatre Friends to refurbish the facility. This photograph taken in the early 1970s shows the butcher shop, jewelry store, and Dick LaMotte's barbershop alongside the theater. (Courtesy of Momence Theatre Friends.)

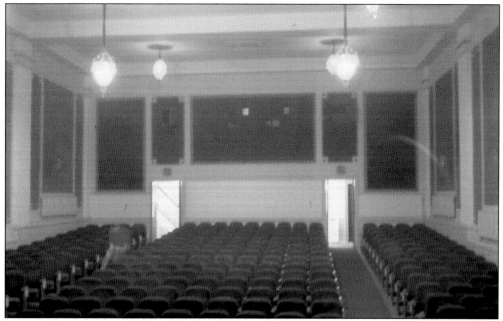

MOMENCE THEATRE INTERIOR This is a very rare photograph of the interior of the Momence Theatre. The theater had a sizable stage and functioned as a movie house and live theater. Very few photographs of the interior exist. Today the inside has been gutted in preparation for future renovation. The theater was built in 1924. (Courtesy of Momence Theatre Friends.)

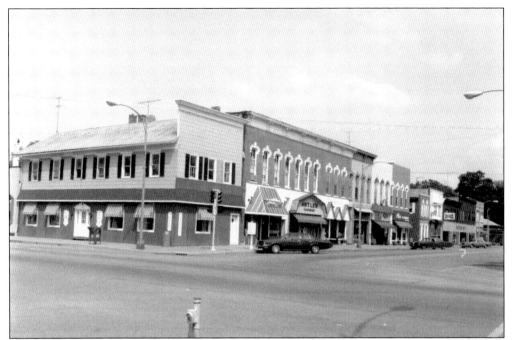

FACE-LIFT, 1970S. One of the more iconic blocks in Momence received a face-lift in the 1970s as local merchants strove to fight off competition from malls. Like most small-town business districts, the development of malls and later big box stores put pressure on local stores that could not compete with large chains. Momence hung on and chose an antique theme for its downtown. It made shopping in Momence special during these tough times. (Courtesy of the Progress Reporter.)

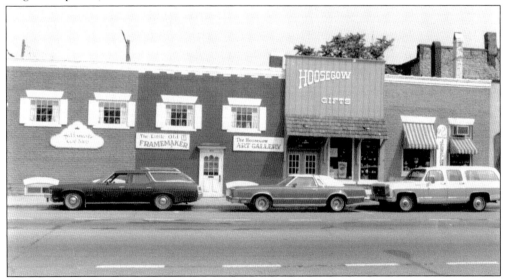

HOOSEGOW, 1970S. As part of the redevelopment theme, the Hoosegow was developed along with storefronts on Washington Street. This unique remaking of the business district allows Momence to extend its commercial life beyond similar communities that were impacted by national chains and malls. Hugh Butterfield was active in the development of this project. (Courtesy of the Progress Reporter.)

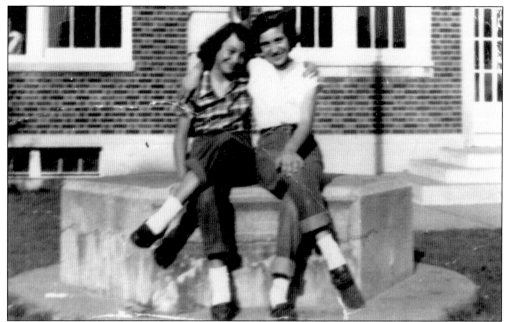

SCHOOL CHUMS, 1950S. Kay Fite (left) and Betty Dionne pose in front of Momence High School in the 1950s. They are sitting on the flag stand, which provided a natural spoke for kids to sit and visit. Both ladies are still in Momence and friends to this day. Lifelong friendships begin in small towns like Momence and often extend for years. Both girls are wearing the fashions of the decade. (Courtesy of Kay Fite Laue.)

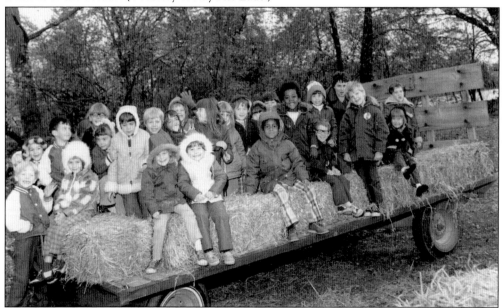

HAYRIDE. These young schoolmates from Momence enjoy a hayrack ride on a cool autumn day. Like all American towns, Momence lives and works for the children of the community. School pride and special events for kids are important to every family in Momence. It also creates the next generation of residents who will shape the future of the town. (Courtesy of the Progress Reporter.)

JOE PIEKARCZYK. Momence is full of dynamic personalities, and few could compare to Joe Piekarczyk here pictured with a few pet rocks. Pet rocks became a craze in the 1970s, and Piekarczyk had a way of spoofing anything. The Piekarczyk brothers were in construction and did masterful work. The author recalls watching them build steps at St. Patrick's Church in the 1960s. It was a laugh a minute. (Courtesy of the Progress Reporter.)

FIVE GENERATIONS. Five Generations of O'Brien ladies posed for the birth of Jennifer Dau, including her mother Debbie Saindon Dau, Ellaine O'Brien Saindon, Virginia Peterson Miller, and Bonnie Miller O'Brien. In addition to lifelong friendships, multigenerational families form the glue that holds communities like Momence together. (Courtesy of the Progress Reporter.)

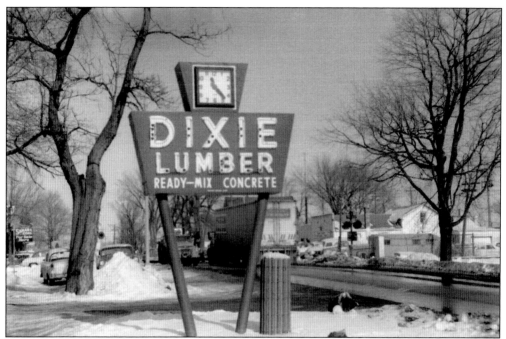

DIXIE LUMBER. Dixie Lumber Company thrived during the postwar building boom of the 1950s and 1960s. The sign on Dixie Highway, complete with clock, welcomed travelers to Momence for years. Dixie Lumber Company also built a number of houses in the community. Momence had adequate resources for rapid growth during the boom years following the war. (Courtesy of the Progress Reporter.)

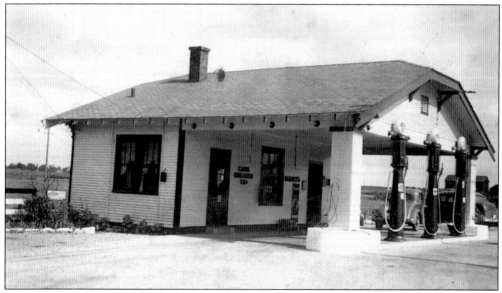

NORTH END STATION. An early photograph in the 1940s of the gas station at the north end of Dixie Highway marked the edge of town for many years. A closer look reveals that one could get their car greased for 50¢. Today an expanded shopping area exists there and the community has grown north with new homes and additional shopping beyond the old north end. The station was owned by Barney Broulette. (Courtesy of the Edward Chipman Library.)

FORMING FRIENDS. Members of this group of young students await their next move at school, and a few seem a little tired of the wait. The school environment is where the community most often comes together today. Momence schools have grown west in Momence as a new junior high, elementary, and Christian school now set west of the high school. (Courtesy of the Progress Reporter.)

LASTING FRIENDS. These same adults were schoolmates some years ago (class of 1952) and gather to remember old times and reacquaint each other with their current state in life. Momence has often held multiple class reunions that have been successful. The link to Momence usually includes a link to the school, and Momence residents respect and honor their personal and community history. (Courtesy of the Progress Reporter.)

EMERGENCY RESPONSE. The Momence fire department responds to a restaurant fire on Dixie Highway. The building was eventually lost and created an empty space that was purchased by the city. Years later, the city created a park and gazebo in the space and dedicated it to former alderman Greg McDonald. (Courtesy of the Momence Fire Department.)

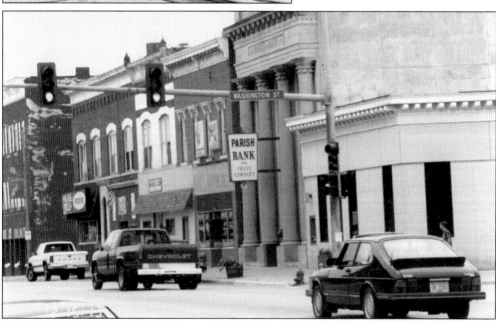

MOMENCE, 1970S. The look of Momence had changed by the time it entered the 1970s. Some businesses were gone, and many changed names. The Parish Bank and Trust Company was an early arrival to Momence. The modern overhead stoplight came later. The corner building next to Parish is new, and the American Legion and VFW have taken their place on Dixie Highway. (Courtesy of the Progress Reporter.)

Five
RURAL NEIGHBORS

CLASSIC BANK. In 1858, C. C. Campbell purchased 160 acres of land from the government in the area where Grant Park is situated today. The town was platted in 1869 and was named Grant in honor of the president. In 1870, Campbell added the word park to Grant to distinguish it from another town of the same name. The Grant Park Bank is now city hall. (Courtesy of the Grant Park Historical Society.)

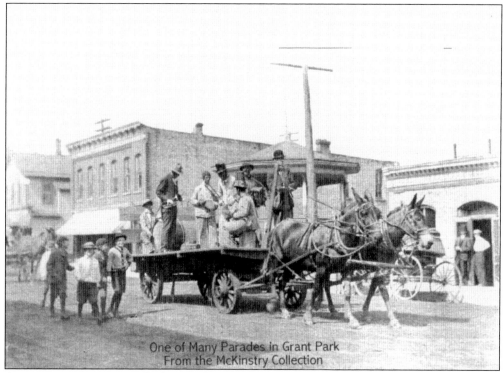

CHASING WAGONS. Two donkeys pull a wagon carrying a musical collection of entertainers in the Gleaner Parade down Taylor Street in Great Park. It appears to be in the late 1800s. Townspeople observe from the sidewalk, but the youngsters trailing the wagon cannot resist joining in the parade. (Courtesy of the Grant Park Historical Society.)

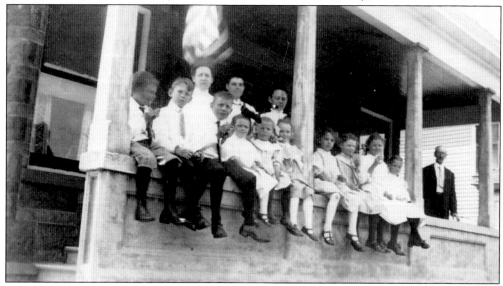

PORCH PARTY. An unidentified group of youngsters poses for a photograph on the porch in Grant Park. Grant Park is five miles north of Momence and shares a common rail line and a history of the Potawatomi Indians with Momence. Families overlap, but the history of the town is distinguishable from Momence to its south. (Courtesy of the Grant Park Historical Society.)

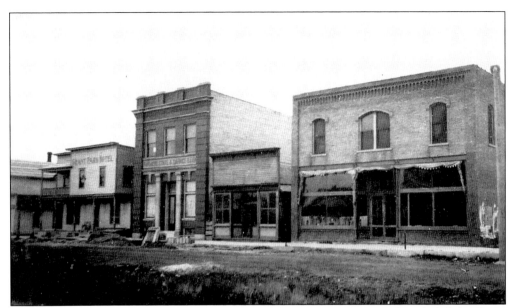

MAIN STREET. Early Main Street development in the 1800s in Grant Park included the Grant Park State and Savings Bank and the Grant Park Hotel. The rail line through town is the focus of the downtown district. Grant Park elected J. T. Rexford as its first mayor. He served from 1883 to 1885. (Courtesy of the Grant Park Historical Society.)

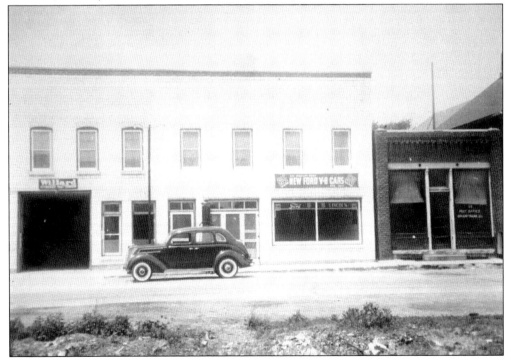

FORD GARAGE. Modern times following World War II afforded Grant Park to have its own Ford dealership downtown. Ford had a product designed to attract the common middle-class citizen to automobiles. Once rail service and mail service was assured, the village witnessed a large influx of businesses to town between 1872 and 1873. (Courtesy of the Grant Park Historical Society.)

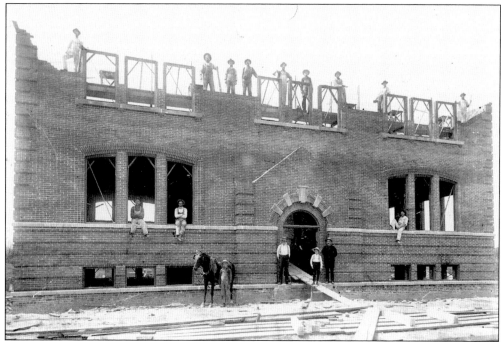

BUILDING THE SCHOOL. The first school opened in Grant Park in 1870 following a few years of struggle involving a previously established school district called Judson. This particular photograph shows the construction of the main structure of the high school. One can easily see the raw lumber used to build these structures and assistance gained from using animals to haul heavy materials. (Courtesy of the Grant Park Historical Society.)

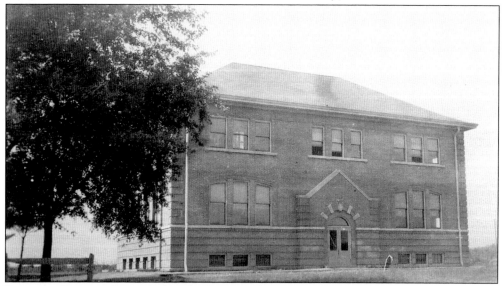

FINISHED SCHOOL. Grant Park School is completed following months of construction work. Previous to the founding of Grant Park, a district school was in place but there was no high school. The high school evolved from a two-year, three-year, and finally to a four-year school in the early part of the 20th century. The Grant Park District was finally established in 1872. (Courtesy of the Grant Park Historical Society.)

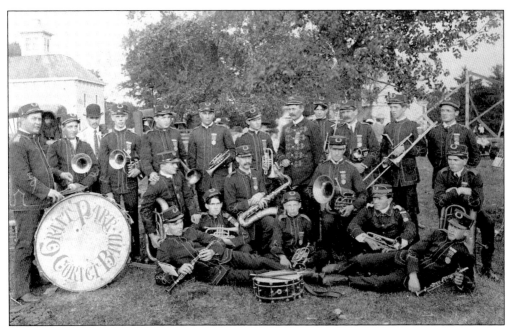

CORNET BAND. Many small communities had bands, which were frequently referred to as cornet bands since the cornet was the primary melodic instrument. This smartly dressed group of musicians from Grant Park poses after a performance in another unknown community. Band music was very popular at the beginning of the 20th century, and most towns supported their own bands. (Courtesy of the Grant Park Historical Museum.)

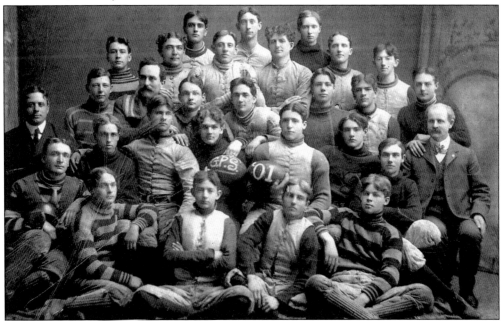

LEATHER HELMETS. Grant Park is unique in that it has never had a high school football team. There were other communities in Kankakee that have not fielded a team as well. In some cases the sport was considered too rough. But some towns like Grant Park fielded adult or nonstudent teams, as this photograph from 1901 shows. (Courtesy of the Grant Park Historical Society.)

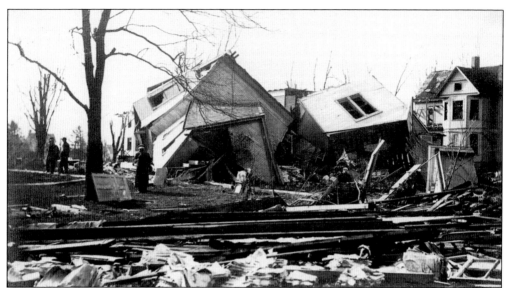

TRAGIC DAY, 1919. An astounding view of the tornado that struck Grant Park in early 1919 reveals the level of damage in the community. It occurred just after 5:00 p.m. The storm bore a 300-foot-wide path through the center of town. Damage to electrical lines kept the city in the dark that evening. Miraculously, no one was killed. (Courtesy of the Grant Park Historical Society.)

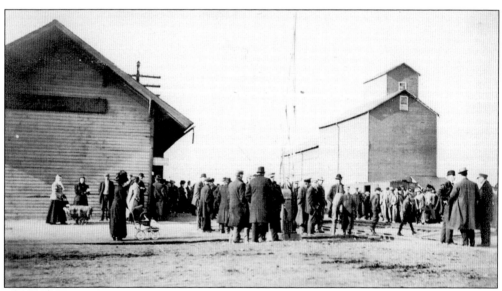

TOWN GATHERS. Nearly 200 people from Momence came to Grant Park following the tornado of 1919. Word reached Momence from train passengers traveling to Momence from Chicago, since electrical lines were down. Townspeople gather at the train tracks following the storm. Numerous improvements to the town were put in place following the storm, including street paving and improved water systems, and the Grant Park Women's Club constructed a library that year. (Courtesy of the Grant Park Historical Society.)

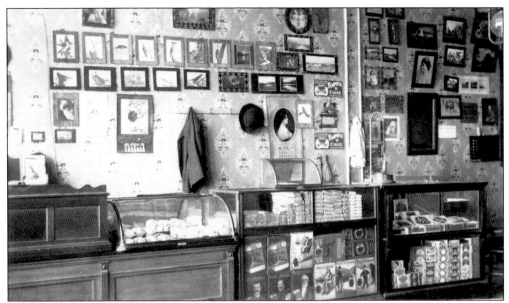

LOCAL SHOP. This photograph from the Grant Park bowling alley shows how different store goods were in the early 1900s compared to today. Cigars, cigarettes, and large packs of tobacco were big sellers during that day. In the display case is a clearly marked bag of Bull Durham chewing tobacco. In 1936, Grant Park counted 36 businesses in town, including one dentist and one doctor. (Courtesy of the Grant Park Historical Society.)

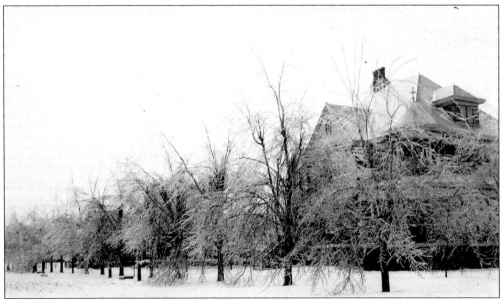

FREEZING RAIN. A hard freezing rain covers the trees that line the street along the famous Bennett-Curtis House in Grant Park. Curtis was a state senator and purchased the house from its original owner named Bennett. Today the house is a restaurant and features high-quality food served in the traditional atmosphere of the home as it was when it was built. (Courtesy of the Grant Park Historical Society.)

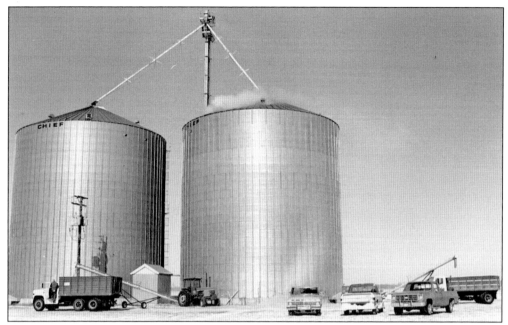

RURAL SKYSCRAPERS. Dotting the rural landscape around Momence and surrounding towns are huge grain elevators that are part of the process of selling agricultural products. One hundred years ago, farmers sold crops locally. As years passed, local products reached domestic markets throughout the country. Today products are sold throughout the world, and distribution methods are highly advanced from previous days. (Courtesy of the Progress Reporter.)

CHANGING FARMS. Albert Smith (left) and his father-in-law, Thomas Johnston, both longtime Momence area farmers, sit and watch the latest farm auction during a time when family farms were selling off assets and leaving the farm business. In some instances, five generations of family farms left the business during these times. Sitting on Albert's lap is his grandson Lucas Smith. (Courtesy of the Progress Reporter.)

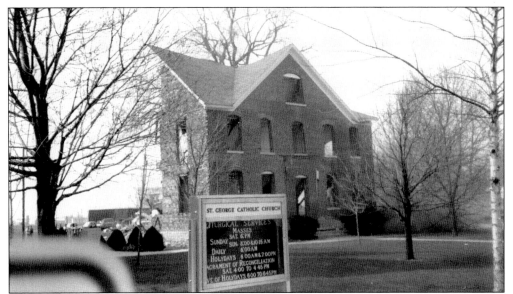

LAST STAND. The front facade of the St. George Convent and School stands ready for the final act of the wrecking ball. Built in 1889, the school served the entire community. The most unique aspect of the school was that it was a pubic school taught by religious sisters. This was not uncommon in Kankakee County rural areas with predominantly Catholic populations. (Courtesy of St. George Church.)

ST. GEORGE CONVENT. Before the convent was built, a public school existed about a mile east of the village before being moved to the village. When the convent was built, the public school was attached to the convent as a kitchen and dining room. It was later removed as a residence. A two-year private high school was added in 1913 and made into a public school before closing in 1948. (Courtesy of St. George Church.)

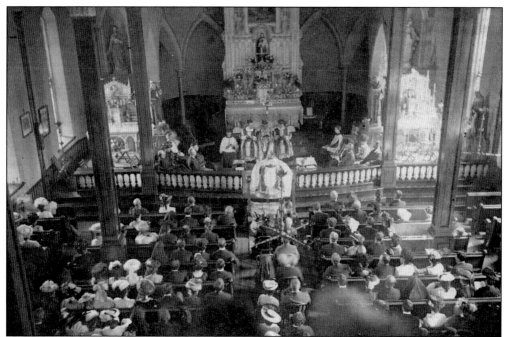

BELL BLESSING. The first church in St. George was a wooden framed church built in 1848. It was a mission church served by the priests at Bourbonnais. A larger wooden chapel was built in 1858. This rare photograph shows the blessing of the bell for the first stone church built in 1869. The bronze bell was removed in the 1980s due to safety and structural issues. (Courtesy of St. George Church.)

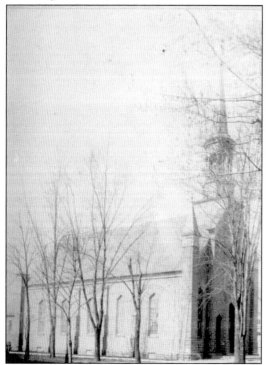

ST. GEORGE CHURCH. The first stone church, built in 1869, was struck by a tornado within months. It was rebuilt in 1872. In the early 1900s, another tornado took off the roof and created heavy damage. Again, it was rebuilt. In 1959, the church burned, save the outer walls. Fire departments from Momence and six other towns fought the flames. Today's church has the exterior walls of the 1872 church. (Courtesy of St. George Church.)

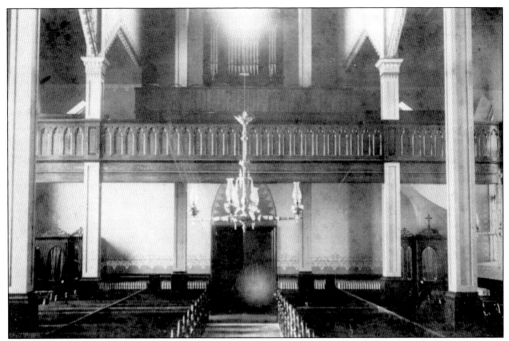

BALCONY VIEW. This interior view of St. George Church shows its balcony and accompanying pipe organ. The great fire in 1959 destroyed the interior of the church, known for its fine woodwork. French Canadians established the village of St. George, and the church drew parishioners from farms in all directions. Today St. George has a new public school and is experiencing growth. (Courtesy of St. George Church.)

THE HALL. St. George Hall served as a social center for the village for many years until a new hall replaced it across the street in recent years. Dozens of family reunions, wedding receptions, and parties occurred in the hall over the years. In the 1960s, it was a favorite spot for young teenagers from all over Kankakee County who attended sock hops on weekends during the time when garage bands were the rage. (Courtesy of St. George Church.)

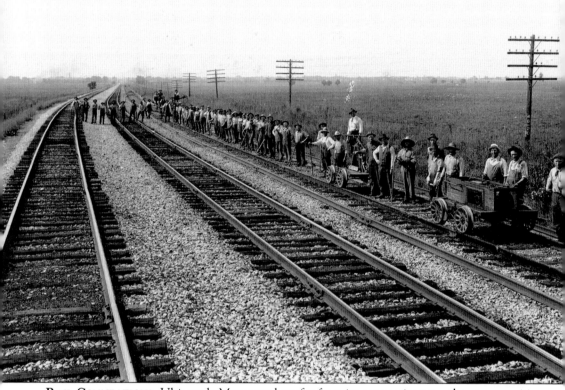

RAIL CONNECTIONS. Ultimately Momence benefits from its connections to other communities and other markets. Roads and rail played important roles in the development of Momence in its early days and will affect its commerce in the future. The railroad built by these workers created opportunities for Momence in their day. They also created a right-of-way for new connections through Momence in the 21st century. (Courtesy of the Edward Chipman Library.)

Six
CHURCH AND SCHOOL

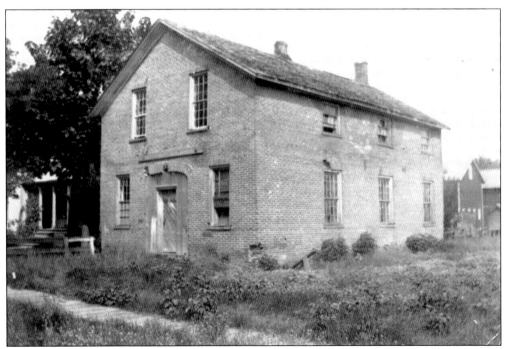

THE OLD BRICK. The Old Brick School was referred to by its abbreviated title by Momence natives that attended the school. Long before the old Central High School was built, this was the only school in Momence. It is not to be confused with the old Mount Airy School, eventually removed and dedicated at Range School. The Old Brick School was eventually torn down. (Courtesy of the Edward Chipman Library.)

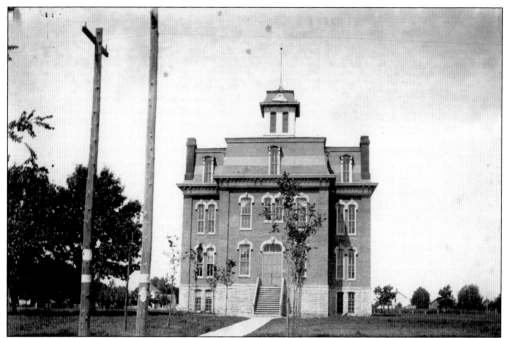

SCHOOL PRIDE. This is a rare photograph of the Union School located where the current Range Elementary School is located. It was a significant addition to the community and was built in 1871 for a cost of $20,000. It served as the high school until the present high school was built in 1936. It had an auditorium and stage on the top floor. A curving walnut staircase served the top floors. (Courtesy of the Edward Chipman Library.)

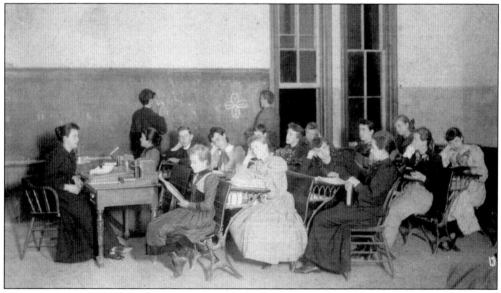

POSED PUPILS. A teacher at Union School poses her students for a photograph. Note the high ceilings in this classroom and the tall window without screens. The class appears to be a biology class based on the drawings being done by the two students at the board. The total number of pupils in the school district at the time was 332. The average annual cost per pupil was $22.34. (Courtesy of the Edward Chipman Library.)

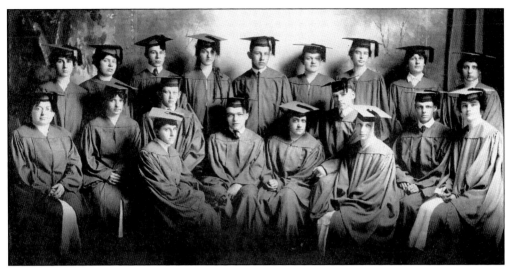

GRADUATES. The year of this particular graduating class appears to be in the early 1930s based on the size of the graduating class. The graduating class of 1893 included only nine students. That year there were only three faculty members. This class appears to be twice the size, so it is likely around the beginning of the 20th century. (Courtesy of the Edward Chipman Library.)

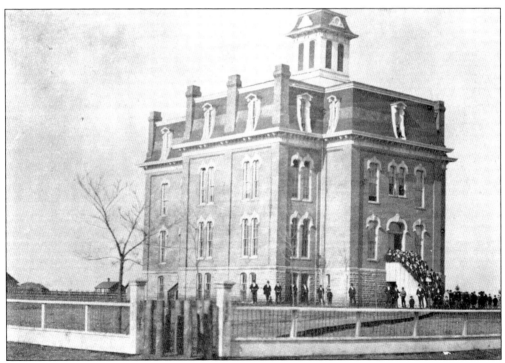

UNION SCHOOL. This second photograph of the school shows a number of adults and students around the school. A more elaborate fence has been constructed around the school, and large timbers have been placed at the gate entrance designed to allow individuals through the gate but perhaps eliminate bicycles, wagons, or horses. It is oddly similar to security structures employed since 9/11, but it was likely used to preserve the grass only. (Courtesy of the Edward Chipman Library.)

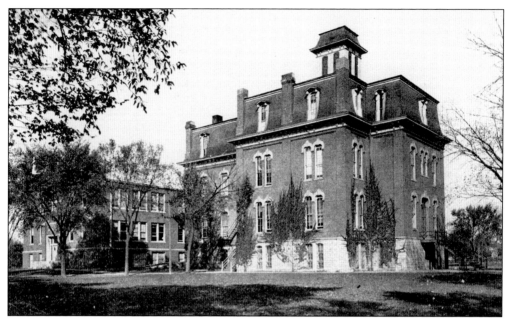

SIDE BY SIDE. This photograph is very unique in that it shows the Central Grade School west of the old Union School around 1916. The grade school had a gymnasium, but the high school played games in the building at the corner of Dixie Highway and Second Street, which is still standing. When the current high school was built in 1936, games moved to the new gymnasium. (Courtesy of the Edward Chipman Library.)

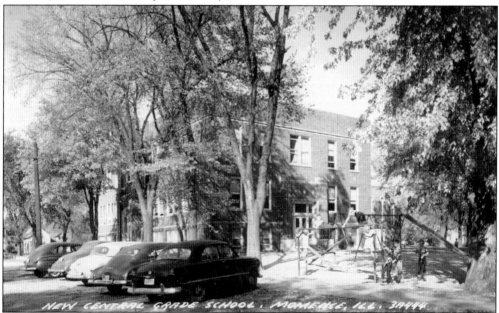

CENTRAL GRADE SCHOOL. If one compares this school to the school next to Union School, one will see modifications, but this is the same school. One can notice young students are playing on the steel monkey bars, something not often found in school playgrounds these days. Anyone that recalls this school will remember the cracker box gymnasium. (Courtesy of the Edward Chipman Library.)

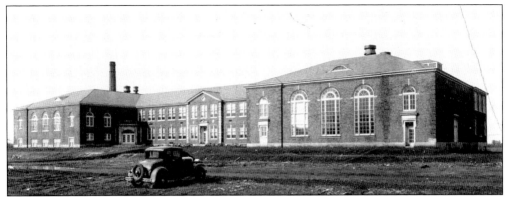

NEW HIGH SCHOOL. One of the earliest photographs of the new high school shows the landscaping before grass was planted. There is very little street or curb development, and the sports complex behind the school is clearly missing. This building has remained relatively unaltered until recently. An addition has been placed on the south end, and on the north end is a new parking lot. (Courtesy of the Momence Historical House.)

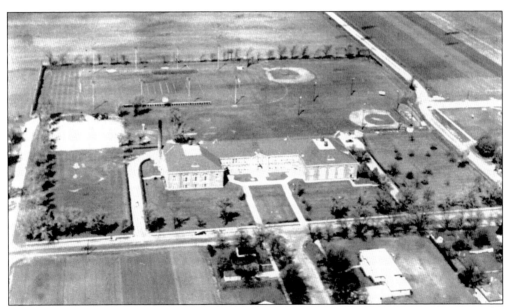

VIEW, 1960s. By 1960, athletic fields and the arboretum had been added to the campus. Note the baseball field south of the high school. Only Hickory Lane exists in the Van Drunen subdivision, and there are many open lots east of the high school. During this time, the seventh and eighth grades were housed on the second floor in the south end of the building. Sixth graders attend Loraine School on the south side. (Courtesy of the author.)

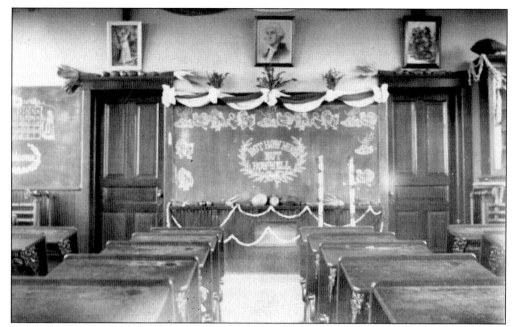

FOURTH GRADE. This rare photograph is of the fourth-grade classroom at Loraine School. The school is named after Loraine Beebe, the first teacher in Momence. She was often interrupted by a curious Potawatomi Indian looking in the schoolhouse window. She was the sister-in-law of A. S. Vail, who built the first schoolhouse in the area. He also named the post office and the area on the city's southeast side Loraine after her. (Courtesy of the Edward Chipman Library.)

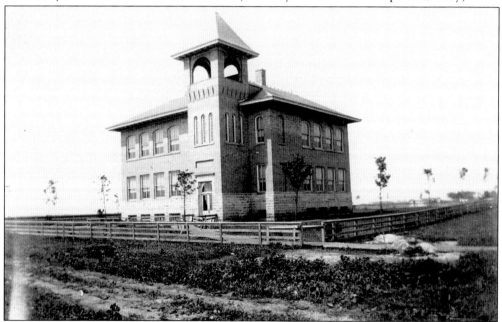

LORAINE SCHOOL. This old south side school was named for Loraine Beebe, who was one of the first, if not the very first, teachers in Kankakee County. Loraine Beebe was born in Vermont in 1812 and moved to Momence at age 24. At one time the settlement at Momence was called Loraine. Loraine School closed in the late 1960s. (Courtesy of the Edward Chipman Library.)

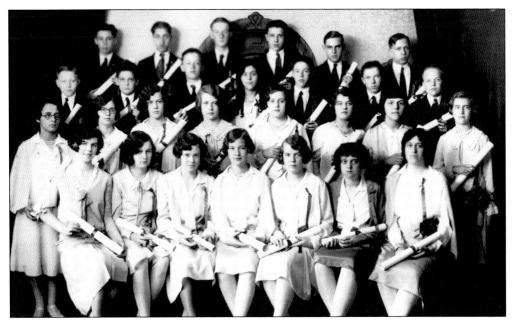

GRADUATES. This photograph shows an early graduation class. Graduation from high school was significant for most young people because it was often the end of formal education. Curriculums were basic and stressed core skills in reading, math, social studies, sciences, and the arts. High school students of every era gravitate to fashion conformity, as is evident in this photograph of similarly clad graduates. (Courtesy of the Edward Chipman Library.)

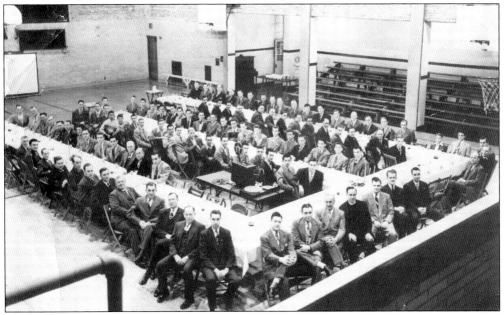

PRIDE OF LIONS. The Lions Club sponsored an honorary dinner for the 1947 football team in the high school gymnasium. Local civic and religious leaders attended this event, and films of recent games were shown. The photograph was obviously an extended exposure since the young lady serving drinks in the back quickly moved to her left creating a dual image of herself during the extended exposure. (Courtesy of the Edward Chipman Library.)

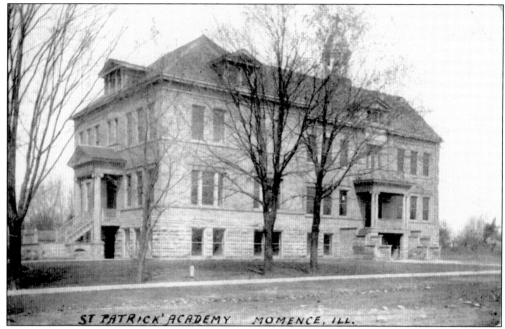

St. Patrick's Academy. This is one of the earliest photographs of St. Patrick's Academy. The school was started by the Sisters of the Holy Heart of Mary and accepted boarding students as well as local Momence students. A nationwide fever created a number of orphans, and numerous boarder schools filled the void. The sisters also started St. Mary's Hospital in Kankakee and had schools in Beaverville and Manteno. (Courtesy of the author.)

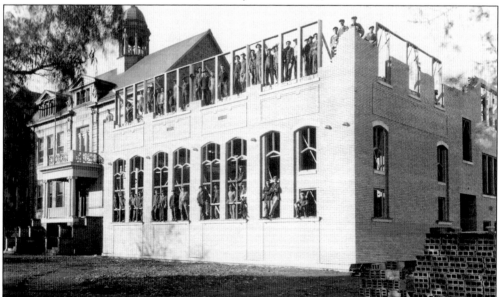

School Chapel. This rare photograph shows workmen constructing the chapel attached to St. Patrick's. The chapel still exists today and provided the sisters with their own place of worship and a convenient location for services on first Fridays when students attended mass as a group. The photograph shows the extensive workforce required to complete such a project. (Courtesy of St. Patrick's Church.)

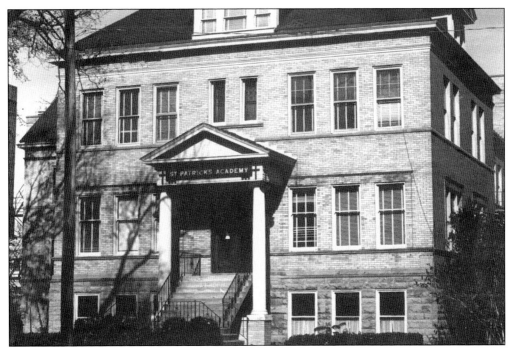

SOUTH FACADE. This familiar side of St. Patrick's housed the administrative portion of the school. It included living quarters for the sisters and a reception parlor for guests. Students and parents rarely occupied this section of the building. Being the oldest section of the school, it was torn down in recent years, creating a new entrance set back from Second Street. (Courtesy of St. Patrick's Church.)

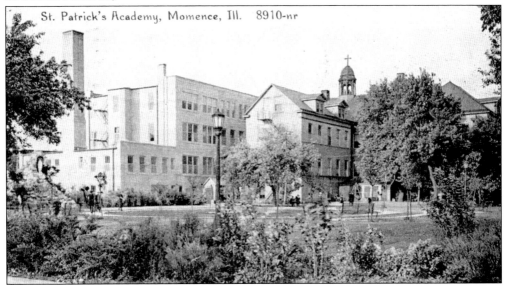

FULL BLOOM. This is St. Patrick's Academy at its peak. The photograph shows what was referred to as the girls' side. Boys and girls were educated in a coeducational environment, but recess was segregated. The grotto and girls' circle are clearly visible. The school included a high school for girls. Many of the boarders were from Chicago and included grade-school boys and girls. (Courtesy of St. Patrick's Church.)

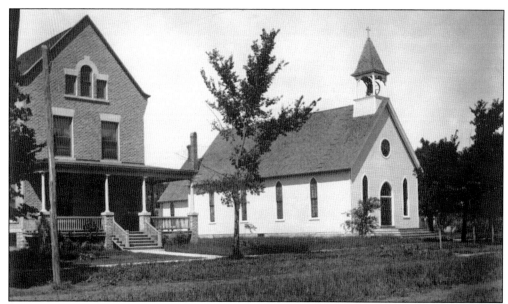

MISSION CHURCH. St. Patrick's Church was originally a mission church supported by St. Anne and St. George. Despite the large number of Catholics throughout Kankakee County, particularly the French Canadians, Catholics came to Momence relatively late in the city's history. Note the dirt street, and in the background one can see that the school has not yet been built. (Courtesy of St. Patrick's Church.)

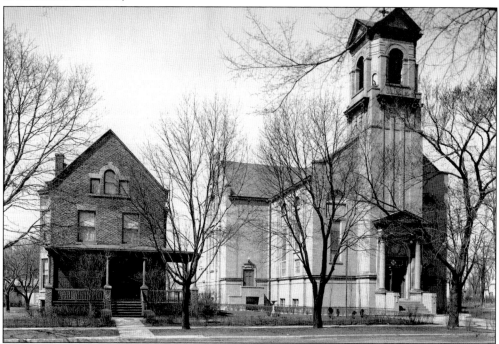

NEW CHURCH. The current church replaced the wooden structure, but the rectory remained the same. At this point, St. Patrick's Academy was open as the growth of Catholics in Momence grew significantly. The church steeple was one of the highest structures in town and featured a nightly bell toll at 6:00 p.m. that usually signaled suppertime for all. (Courtesy of St. Patrick's Church.)

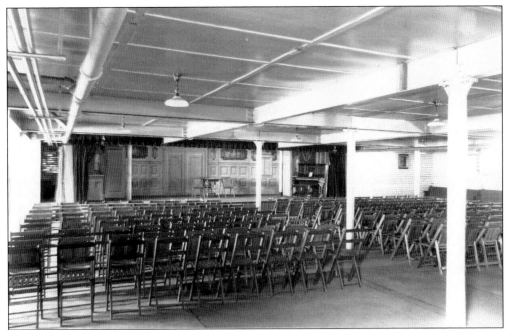

CHURCH BASEMENT. This is one of the few photographs of the church basement, which was used actively for social events, receptions, and parish meetings. During the 1950s, the school population grew extensively and the stage was used as a classroom. Beyond the large number of baby boomers, St. Patrick's experienced a wave of Cuban students following the overthrow of President Batista by Fidel Castro in Cuba. (Courtesy of St. Patrick's Church.)

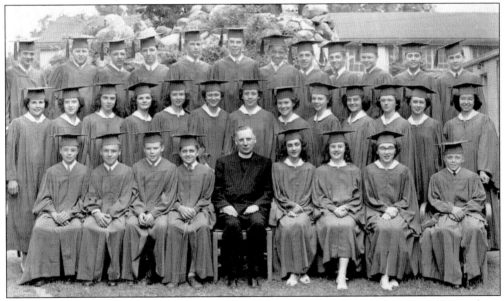

GRADUATES. Pastor Father Demereau sits with eighth-grade graduates of St. Patrick's Academy from 1951 in front of the grotto on the school grounds. Most graduates moved on to Momence High School, but many of the girls moved on to the high school level at St. Patrick's. The school featured a basic curriculum and featured a particularly large amount of music, singing, and other enrichment activities. (Courtesy of St. Patrick's School.)

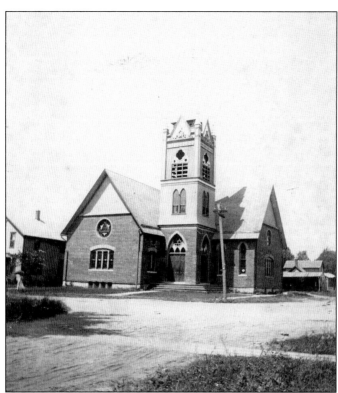

METHODIST CHURCH. When this Methodist church was in existence in Momence it was called the "new" Methodist church. It was torn down to build the current Methodist church, which is located on the same location on Dixie Highway. Archibald Morrison, an old circuit rider, was one of the founders of Methodism in Momence, and he began his work from his home built north of Momence on Vincennes Trail. (Courtesy of the Edward Chipman Library.)

METHODIST WOMEN. This group of religious women, called the Star Club, was active in Momence for a number of years. Ladies' organizations in Momence have played a major role in support of their church and the families in the community. These groups are active today, supporting congregational members and the entire community as well. (Courtesy of the Edward Chipman Library.)

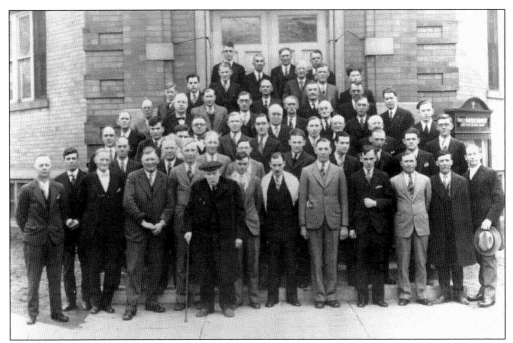

BAPTIST CHOIR. This large group of men consisted of members of the First Baptist Church Choir. They are standing on the steps of the old Baptist church on Dixie Highway that was later turned into a bank when the church moved. The conductor of the choir was Clarence Gilbert, a talented local man who also played a number of instruments. (Courtesy of Betty Gilbert Dionne.)

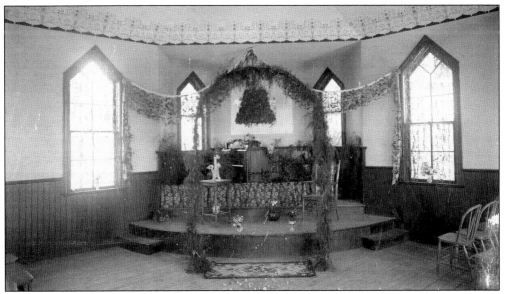

INTIMATE CHURCH. In this photograph, the church is noted as the Dutch Reform Church of Momence. It is a rare view from inside the church. The garland-lined decorations and flowers on the floor seem to indicate that a wedding has just occurred in the church. Notice the rather simple seating and the floorboard. The church organ is tightly placed in the corner area of the church. (Courtesy of the Edward Chipman Library.)

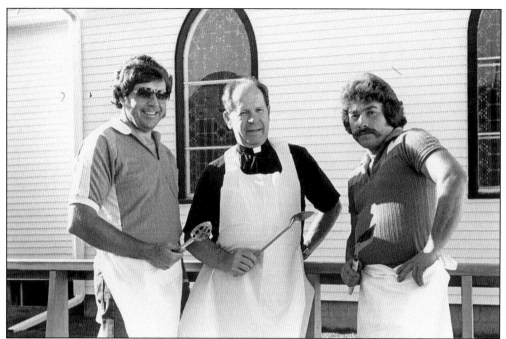

COOK OUT. Reverend Oechel and two members of the Episcopal Church of the Good Shepherd prepare for a fund-raising event in support of the church's activities in Momence. The original church is still in Momence located across from the Edward Chipman Library on east Second Street. On the right is Meryl Chouinard. (Courtesy of the Progress Reporter.)

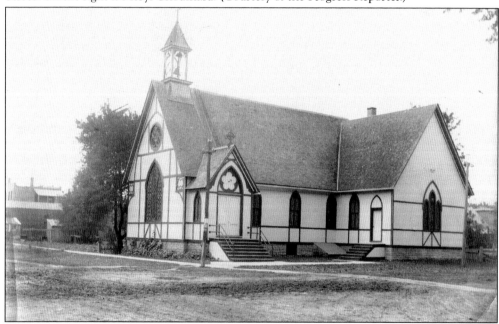

EPISCOPAL CHURCH. The Episcopal Church of the Good Shepherd is one of the oldest churches in Momence and is active in the community. This early photograph of the church shows how little was developed in the immediate area around the church. The look of the early church is quite similar to how it appears today. (Courtesy of the Edward Chipman Library.)

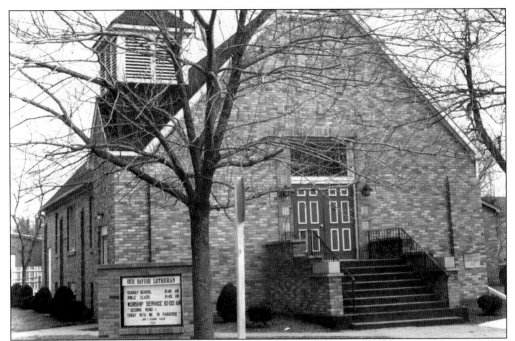

OUR SAVIOR LUTHERAN. Our Savior Lutheran Church located at Second and Pine Streets is a member of the Lutheran Church-Missouri Synod and has been a significant part of religious life in Momence for a number of years. The brick building is very much like it is today. Momence has always had active Christian churches, which have supported the religious and personal needs of its citizens. (Courtesy of the Progress Reporter.)

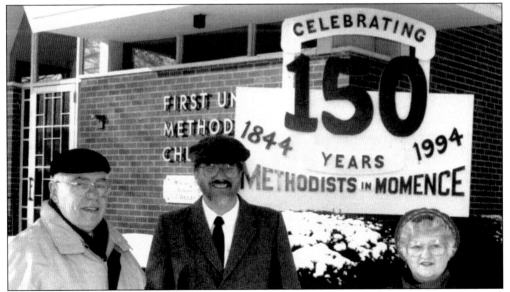

METHODIST MOMENT. The First United Methodist Church celebrates its 150th anniversary. From left to right are Les DuMontelle, Rev. Wesley Wilkey, and Ann Newberry. DuMontelle was an active proprietor in Momence and a town promoter. His father was also a storekeeper in Momence. The Methodist Church has played a significant role in the history of Momence and in the lives of its congressional members. (Courtesy of the Progress Reporter.)

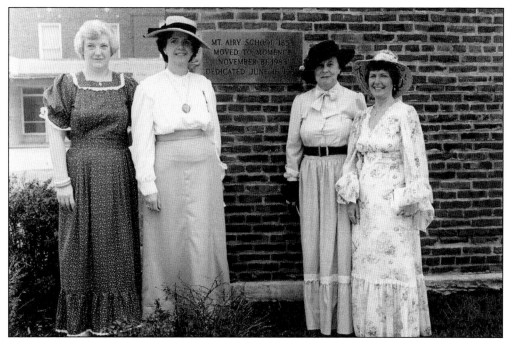

LEADING WOMEN. Ava Parish (third from the left), the longtime chairman of the Momence Gladiolas Festival, pauses with other women leaders at the dedication of the old Mount Airy School built in 1853. The ladies are wearing clothes of the period during the sesquicentennial celebration. Pictured with Parish are Carol Morse, Sandra Ortiz, and Marlene DeBell on the far right. (Courtesy of the Progress Reporter.)

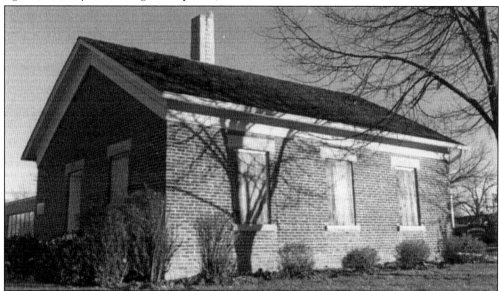

PERMANENT HOME. The Mount Airy School rests on the lawn of Range School. The building was moved from its original site and serves as a museum. Momence has a strong interest in its past. The oldest city in the county is the only city with a frontier history. There are numerous historical markers and preserved buildings throughout the area for current residents to appreciate. (Courtesy of the Progress Reporter.)

Seven
TEAM PLAY AND MELODY MAKING

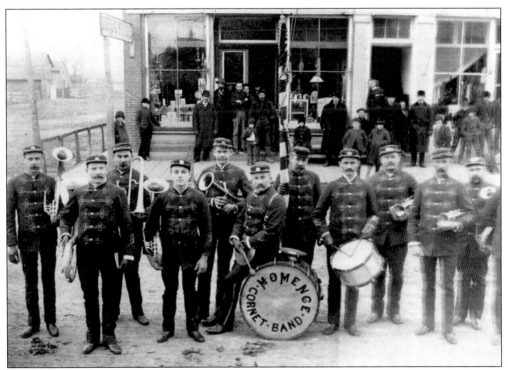

ON THE MARCH. Members of the Momence Cornet Band pauses for the camera as they ready to perform down Range Street. Parades and celebrations have a long tradition in Momence. This photograph shows how eager the citizens of Momence have always been to watch a good parade and enjoy the music of the day. This photograph was taken looking west at the corner of River Street and Range Street, which is now Dixie Highway. (Courtesy of the Edward Chipman Library.)

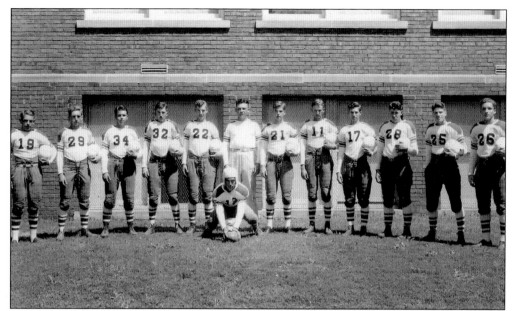

CONFERENCE CHAMPS. The Momence Football Team was a back-to-back champion of the conference in 1935 and 1936. Many notable Momence citizens are pictured here, including John Cecil (19), Stan Hardy (29), Ralph Esson (34), Earl Case (11), Lawrence Rehmer (22), John Halpin (21), Tody Bukowski (17), Bob Roulette (28), and Phil Hardy (26). The coach was Mr. Moss. Ken Prairie is over the ball. (Courtesy of Velda Case.)

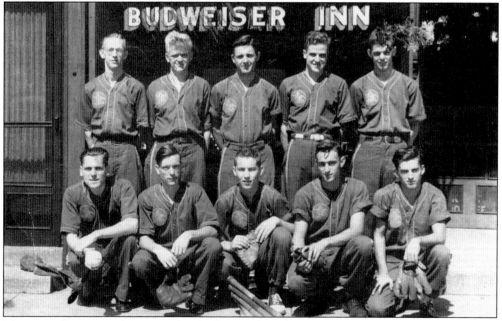

MOMENCE BASEBALL. Momence has had a number of men's baseball teams over the years. In those days, most communities had teams and they played throughout the summer. This team was sponsored by the Budweiser Inn. Not all the players can be identified, but the two men in the second row from the left are Harold Jensen and Chuck Astle. Fred Dennison is fourth from the left standing. (Courtesy of the Edward Chipman Library.)

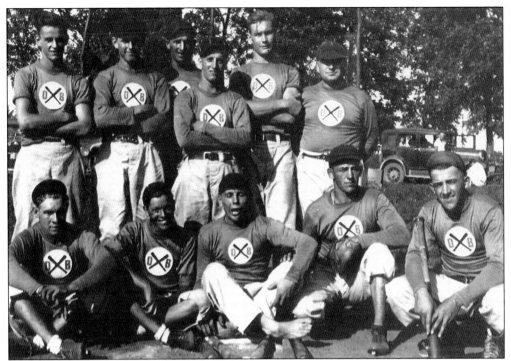

BASEBALL BUDDIES. Another rambunctious group of teammates from Momence celebrates a victory. Few of these players have been identified, but the team appears to be from the 1920s based on the style of uniform and the automobile in the background. The competitive spirit of Momence continues today as townspeople support the youth and school teams each year. (Courtesy of the Edward Chipman Library.)

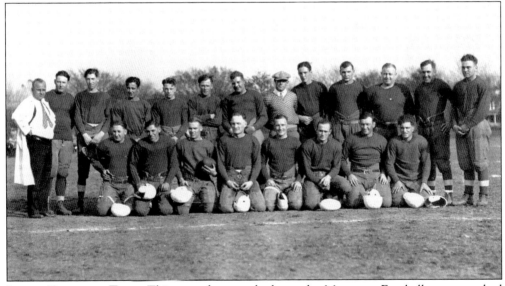

LOCAL FOOTBALL TEAM. This rare photograph shows the Momence Football team coached by C. E. Reising. This was an adult team. Momence High School also fielded a team, but a few towns featured adult teams. This group of players consists of young men in their prime. The team played during the 1920s and 1930s. (Courtesy of the Edward Chipman Library.)

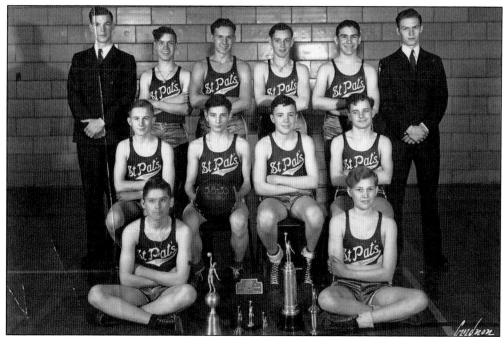

TROPHY WINNERS. St Patrick's Academy fielded boys' basketball teams for many years. They had a functional gymnasium and played other parochial schools as well as public schools. The gymnasium is still located on the school campus today and has changed little. While not all the players are identified, coach Lawrence Rehmer is standing in the back row on the left. (Courtesy of St. Patrick's Church.)

MODERN ERA. The tradition of basketball at St. Patrick's continues today. Here a team from the early 1970s poses for a team photograph. Notable was the square wooden backboards in the gymnasium. In a day when "set shots" were common, players developed elaborate bank shots off this type of basket, a skill rarely developed for today's game. (Courtesy of Marilyn Jensen Peterson.)

FAST PITCH. Very popular in more recent years was the arrival of girls' softball to communities and schools all around Illinois. This occurred primarily due to new laws on the books requiring similar extracurricular opportunities for girls as well as boys. Here one of Momence's school teams poses for a team photograph. (Courtesy of the Progress Reporter.)

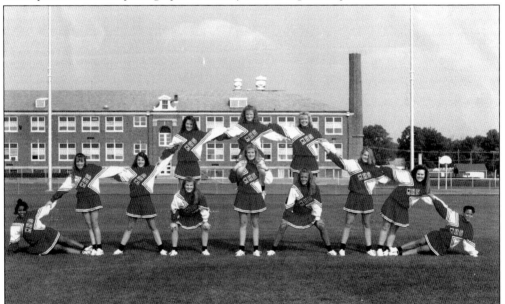

CHERRY AND WHITE. Another outlet for girls has been the activity of cheerleading. Once a sideline activity, cheerleading has become a competitive sport in itself. School squads spend time at training camps in the summer and participate in competitive cheerleading events. Here the squad from Momence creates one of its unique formations for the camera. The Momence cheerleaders have won numerous contests over the years. (Courtesy of the Progress Reporter.)

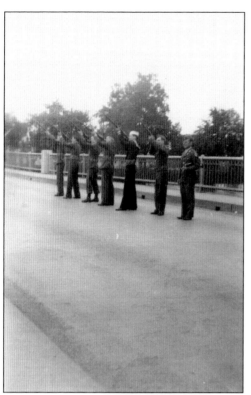

FALLEN HEROES. Comradeship among veterans is always strong. Memorials to fallen heroes in Momence have always been of particular importance to the community. Here a firing squad offers a salute to Momence natives who have given their lives for the country. The photograph was taken on the Momence Bridge. Standing by, ready to play taps, is skilled trumpeter Eddie Prairie from Momence. (Courtesy of Issy Prairie.)

HONOR AND RESPECT. The Momence Honor Guard is a proud addition to Momence's tradition of honoring those who have passed. The group of high school students was started by local funeral director and veteran Bill Cotter and performs the memorial duties once fulfilled by veterans' groups that have become fewer in numbers. The faculty advisor on the far right is Richard Degitz, former music teacher at Momence High School. (Courtesy of the Progress Reporter.)

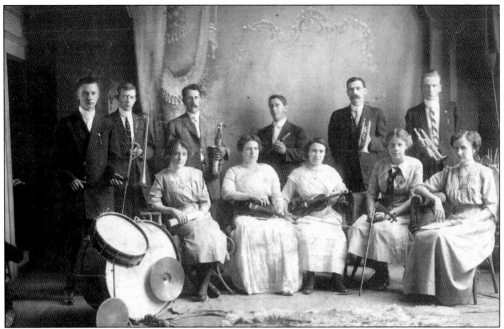

MOMENCE ORCHESTRA. This is a rare photograph of the Momence Orchestra. Cornet player Ed Gilbert, who is pictured in the back row second from the right, led this group of adult musicians. The photograph is unusual because of its date and the presence of a jazz-style drum kit staged in the foreground. Ed played many instruments and was a talented musician. (Courtesy of Betty Gilbert Dionne.)

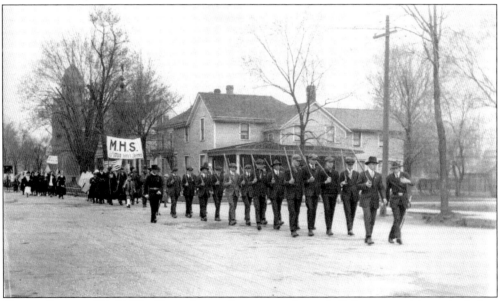

THRIFT STAMPS. World War I brought out the patriotic fever of all American citizens, including this group of young Momence students marching south on Range Street. There is a color guard and a marching troop, and the band is in the rear of the procession. The banner indicates that Momence students have sold 1,700 thrift stamps in support of the war effort. (Courtesy of the Edward Chipman Library.)

EQUESTRIAN ELEGANCE Little is known about this photograph or what occasion brought on such elegant ornamentation of horse and buggy. What it does indicate is how much experience Momence people have at producing public entertainment events and ceremonies. This sense of production has been present throughout the city's entire history. (Courtesy of the Edward Chipman Library.)

SINGING SENSATIONS. Passing on the traditions of Momence, this group of young singers, led by director Karol Carlson, performed as part of the sesquicentennial held in 1984. As was done at the 1934 centennial, local residents produced a town pageant that was performed on the Island Park and was attended by hundreds of local residents. (Courtesy of the Progress Reporter.)

VOYAGER REENACTMENT. As part of the 1984 sesquicentennial, local Momence residents re-created the arrival of Father Marquette and Louis Joliet at Momence, then inhabited by the Potawatomi Indians. Many of their writings describe the Kankakee River in ways strikingly similar to how it might be described today. Here Momence performers arrive by canoe, as the early voyagers would have done in the 1600s. (Courtesy of the Progress Reporter.)

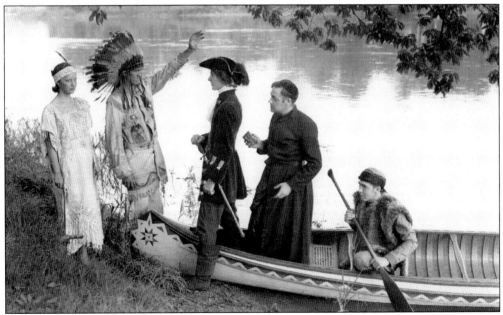

CENTENNIAL PAGEANT. The 1934 centennial pageant featured live reenactments of Momence history, including this depiction of Father Marquette meeting Chief Tippecanoe. Roy Hess, architect of the Momence Gladiolas Festival and husband of teacher/author Kay Hess, played Father Marquette. Charles McNulty, grandfather of the author, played the chief. (Courtesy of the Edward Chipman Library.)

PERFECT PRECISION. In 1951, Frank Hyrup started the Momence Men's Color Guard. This group of World War II veterans was national champions and state champions numerous times. They created a legacy within the activity and a significant contribution on the part of the highly precise group. Here their precision is easily seen on parade. (Courtesy of Paul Hyrup.)

DRESS RIGHT! The Momence Men's Color Guard dresses their front to leader Paul Hyrup. This color guard was called the Momence Color Guard but was later referred to as the men's guard once the White Tornado Girls Color Guard arrived. The group dissolved as the young veterans grew busy with family commitments. The same men would be instrumental in the formation of the White Tornados. (Courtesy of Paul Hyrup.)

GIRLS GUARD. The White Tornado Color Guard was nationally known for the same accuracy and precision as the Momence Men's Guard. After the men's guard disbanded, Dee Cryer asked Paul Hyrup if he would put together some of the local girls for the Gladiolas Festival. It was to be a one-time event. Hyrup went to DuMontelle's and bought the girls a simple uniform and they marched in the parade. The group lasted nearly 20 years. (Courtesy of Bill Buck.)

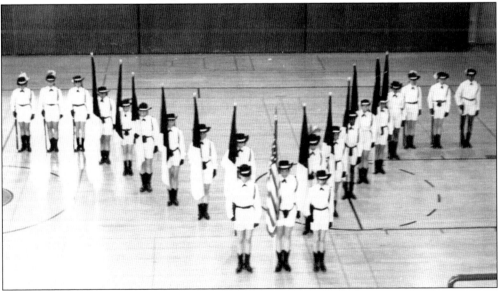

V FORMATION. The White Tornadoes went on to become multiple state and national champions and set a standard for aggressive precision on the part of all color guards, both girls and boys. The young ladies were mostly Momence girls. Guard sergeant Paula Hyrup is at the far right front. She was also a regular winner as top guard sergeant during her time with the guard. Today the Hyrups live in San Antonio. (Courtesy of Kathy Sherwood Sievers.)

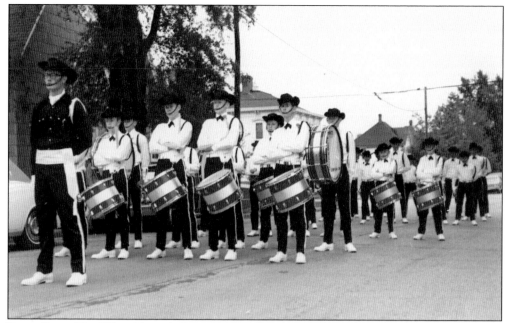

DRUM LINE. The White Tornado Drum and Bugle Corp was formed around the girls' color guard in the mid-1960s. This photograph is the very first time that the drum corp was in uniform. A group from the men's color guard, many of whom were the fathers of members in the corps, built the corps with mostly local kids. Over the years, nearly 2,000 kids were involved in White Tornado activity at one time or another. (Courtesy of Brian Prairie.)

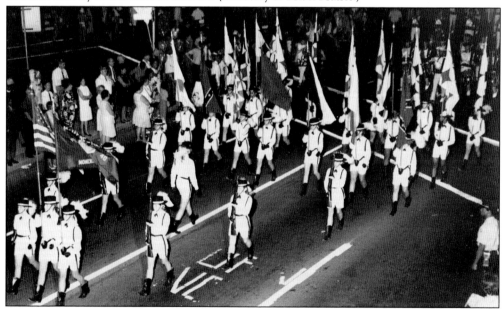

ATLANTA, 1969. The White Tornados Drum and Bugle Corp and Color Guard march in downtown Atlanta, Georgia, in 1969 for the national championships held that year. The corps did quite well that year, making a strong showing at the Illinois State Fair and other contests through the Midwest. Herscher band director Dale Hopper was the music instructor. Paul Hyrup served a marching and maneuvering instructor and director. (Courtesy of Paul Hyrup.)

SWEET SINGIN' TRIO. The Prairie family was a very talented family. It included Eddie, Jean, and Darlene (known as "Muffy") shown here with her Sweet Singin' Trio. Following the death of her brother Eddie and the departure of Jean for California, Muffy continued to perform around the area. Members of this 1950s trio include Reg Chamberlain and Chuck McNulty, father of the author. (Courtesy of the author.)

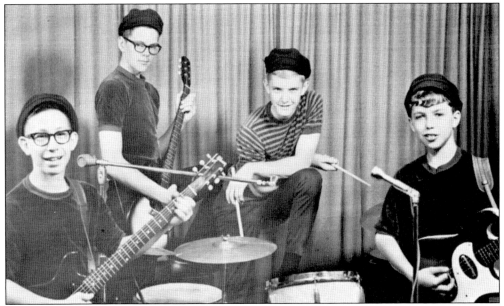

THE OUTRYDERS. In the 1960s, music took a turn. All over America self-taught musical groups, now referred to as garage bands, formed to play teenage dances. Garage bands referred to where these young musicians rehearsed. The Outryders from Momence included, from left to right, Danny Loftus, Dave Valincourt, Kevin McNulty, and Larry Rehmer. They did, in fact, rehearse in Larry's garage on Sycamore Street. (Courtesy of the author.)

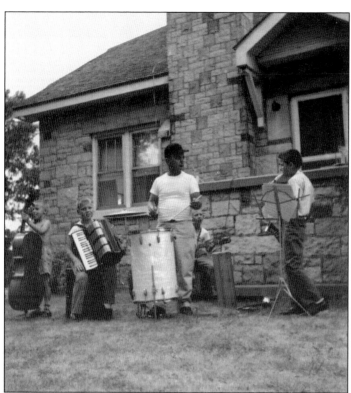

YOUNG SWINGERS. Eddie Prairie entered the service during World War II. His natural talent as a musician encouraged him to audition for the military band. He did so and was admitted to West Point as a member of the band. He later played professionally. Here he teaches his sons and nephews how to play. From left to right are Tim Petro, Dale Prairie, Eddie, Scott Prairie, and Mike Petro. The kids were one of the youngest dance band performers in the area. (Courtesy of Issy Prairie.)

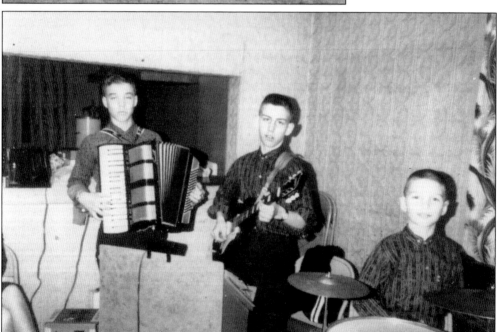

THE PRAIRIE KIDS. Dale, Scott, and Brian Prairie played together as kids in grade school. Their father, aunts, and grandfather were all quite musical. Anyone who saw the kids perform was struck by how good they were at such a young age. Here Dale on accordion, Scott on guitar, and Brian on dad's "cocktail set" play a job at a local hall. (Courtesy of Issy Prairie.)

Eight

THE FESTIVAL

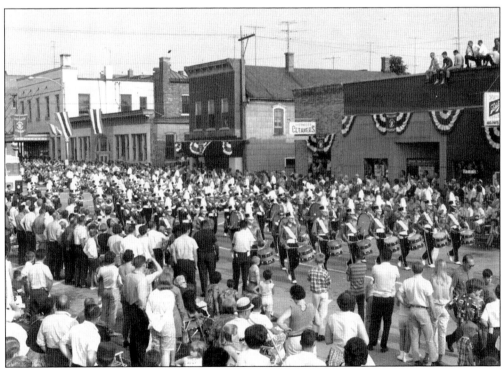

WOW, THE WAY IT WAS. At the peak of the Gladiolas Festival in 1966, the Chicago Cavaliers, as they were called then, thrill the Washington Street crowd as they march their way to the high school. This was the Saturday parade, the biggest of the three parades. If one came to Momence for only one day of the Gladiolas Festival, this was the day. Notice the huge crowds, including many on the rooftops of buildings. (Courtesy of Brian Prairie.)

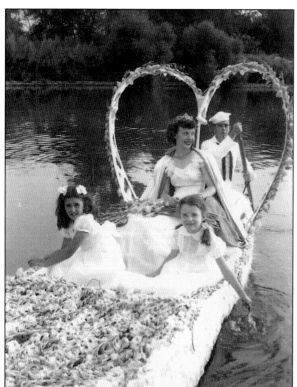

RIVER FLOAT. Unusual today, this was an early river float used during the early days of the festival. This float would be the queen's float with a young princess or kids queen, as they were called, in attendance. Not surprisingly during the war years, a local sailor is manning the float. (Courtesy of the Edward Chipman Library.)

MEN OF VISION. Pictured here is the Gladiolas Festival Committee of 1941. From left to right are (first row) president W. W. Therien and vice president Edgar Bonvallet; (second row) vice president Roy G. Hess, treasurer Elmer Deliere, and secretary Arnold Sherwood. Hess was an early visionary of the festival after attending the Tulip Festival in Michigan with his wife, Kay. (Courtesy of the Momence Historical House.)

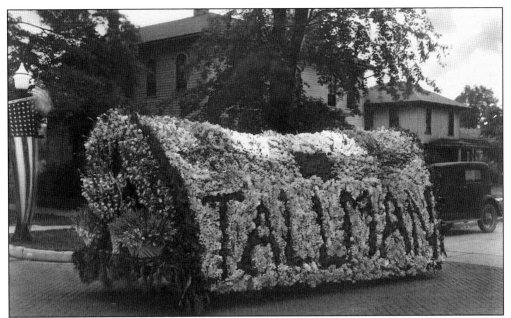

BEFORE THE FEST. This very rare photograph shows a float entry of the Tallman growers. While it certainly looks like an entry in the Gladiolas Festival parade, it was actually a parade of floats one year before the festival officially began. Local growers decided to parade flowered floats through town, and the following year the festival was born. (Courtesy of the Edward Chipman Library.)

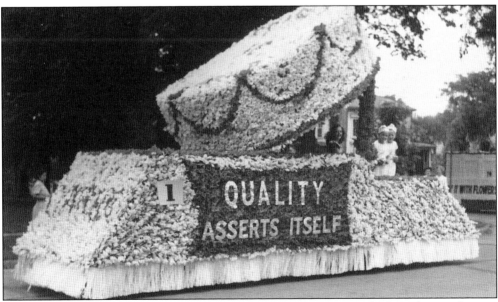

QUALITY ASSERTS ITSELF. Easily recognizable to most Momence people from the era, this was the 1941 entry of Conrad's Bakery in the Gladiolas Festival parade. The company motto is on the float. Local businesses and business groups participated in the event by sponsoring, and in many cases building, floats made of gladiolas. Notice the two young bakers peering out at the camera along with the mandatory pretty young coed. (Courtesy of the Edward Chipman Library.)

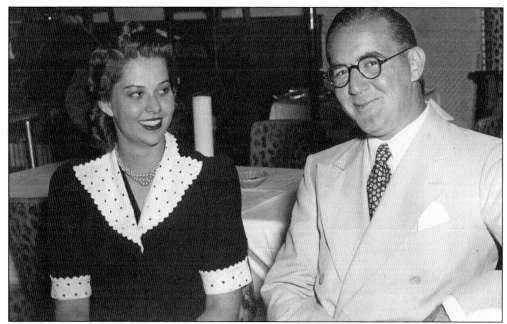

GLAD BENNY. In the early days of the festival, publicity was widespread and significant. In 1941, the Gladiolas Festival queen and her court traveled by train to Chicago to appear on radio shows and promote the festival. Here Gladiolas Festival queen Ruby Graves from Lowell, Indiana, meets none other than Benny Goodman, the "King of Swing," at a Chicago radio program to promote the festival. (Courtesy of the Momence Historical House.)

QUEEN AND HER COURT. The year of this queen and her court are unknown, but it demonstrates a typical coronation of the local queen and her court. In those days girls from surrounding towns could also run for queen until later years when the pageant was limited to local high school girls. For a few years, the princess was called the "kids queen." (Courtesy of the Edward Chipman Library.)

HOLLAND ROOTS. The gladiola growers of the area were actually in the Witchert area south of Momence. At its peak there were nearly 600 growers of gladiolas in the region. Looking to promote the significance of their industry to the rest of the country, the gladiola growers worked with Momence officials to promote the flower and the town. The roots of many of the growers were Dutch, as represented on this wonderful float from the late 1930s. (Courtesy of the Edward Chipman Library.)

MODERN MARVEL. If Momence natives wonder how large some past festival floats were, this one should put any arguments to rest. One of the largest entries from 1941 shows a full locomotive covered with flowers. It is unclear how the float actually moved, but one can be certain that the driver was not the young lady in the white top hat at the rear. (Courtesy of the Edward Chipman Library.)

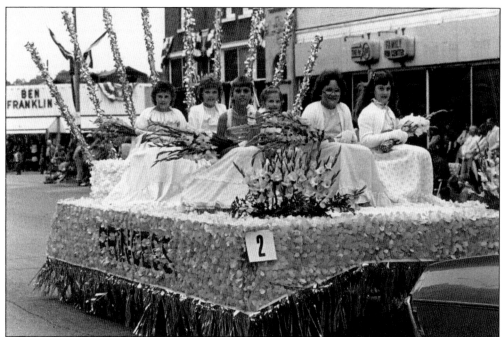

PARADE PRINCESS. The Gladiolas princess and her court, during the late 1960s, ride down Washington Street on a rather chilly festival day. Queen and princess candidates campaign for their office and the whole town votes, culminating in a pageant to crown the winner. Longtime Momence people will recognize the Ben Franklin and other active stores in the background. (Courtesy of the Edward Chipman Library.)

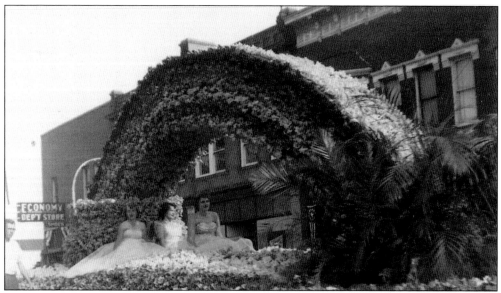

RAINBOW FLOAT. This beautiful entry from the 1950s is from the Glad Growers Association of the area. Their floats usually featured an unusually large number of gladiolas, as is evident in the large entry. The Economy Department Store is clearly visible in the background as the float drifts down Washington Street just east of Dixie Highway. (Courtesy of the Edward Chipman Library.)

SHEEP'S CLOTHING. The kid's parade on Thursday afternoon is a favorite of all Gladiolas Festival attendees. Many very creative entries have created significant memories over the years. Here Little Bo' Peep escorts her unique lamb down the parade route as others look on in wonderment. A closer look reveals that this goat is dressed for the occasion, which brings a big smile to the faces in the crowd. (Courtesy of the Edward Chipman Library.)

FAMILY ENTRY. Kid's parade entries are often family affairs, and by the looks of these three, they are truly brother and sisters. The annual entry in the kid's parade for families of Momence was often more significant than Halloween. Some families entered their kids from the very beginning. Locals looked forward to the more creative family entries that always seemed to be something special. (Courtesy of the Progress Reporter.)

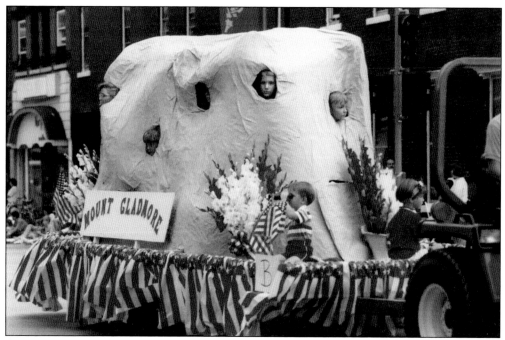

CLOSE-UP VIEW. This family entry is titled Mount Gladmore. There is always a play on words involving words like gladiolas, glad, gladland, gladzooks, or in the this case a spin on Mount Rushmore. Notice the young lad eyeing the crowd with his binoculars in the front. (Courtesy of the Progress Reporter.)

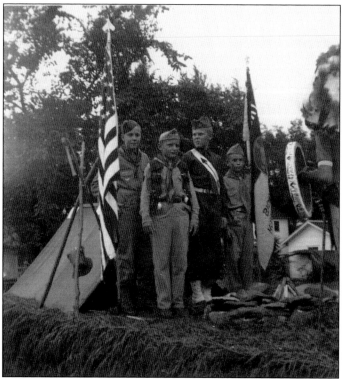

SCOUTS HONOR. Local Scouts take their place atop one of the floats entered in an early 1960s parade. The civic, youth, and social groups of Momence all turn out for the annual event. It is a time to showcase their efforts before a large welcoming audience. Kids would stand at attention on such a float for the entire length of the parade and still do. (Courtesy of James LaMotte.)

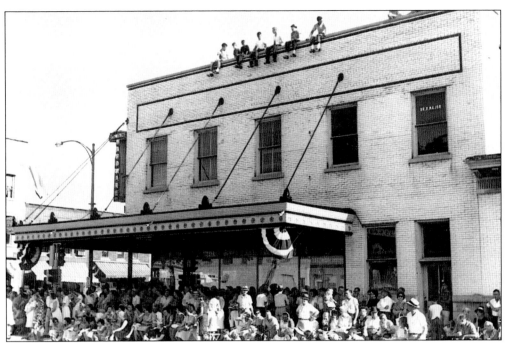

ON THE ROOF. The incredible crowds of the 1960s climbed the rooftops to find a seat for the big Saturday parade. By this time, the old grocery store and later ice-cream shop had become a hardware store but the familiar canopy provided great cover from the sun for the parade. Young men could be seen all up and down Washington Street, hanging out windows and sitting on rooftops for the parade. (Courtesy of the Edward Chipman Library.)

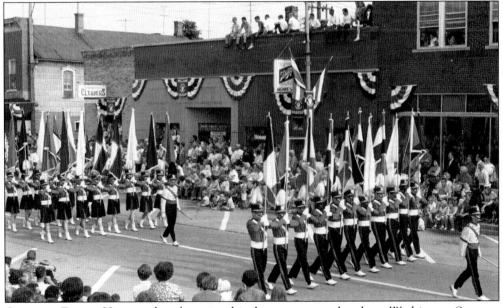

COMPANY FRONT. Here another championship drum corps marches down Washington Street to the high school stadium for the evening's competition. Before drum corps decreased in number, the top corps from around the country came to Momence. It boasted of the longest continuous drum corps show in the country until it was no longer held. (Courtesy of Bill Buck.)

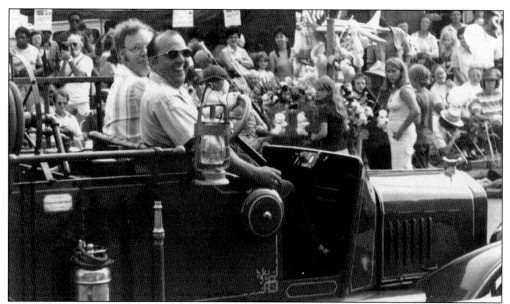

TOM AND JIM. Tom Dennison and Jim LaMotte drive the classic fire department truck down the parade route and turn back to the camera just before pulling away. The unbridled joy of the Gladiolas Festival is no better expressed than on the face of Dennison as he pulls away riding in the truck that appears in previous chapters of this books during the 1920s. (Courtesy of Jim LaMotte.)

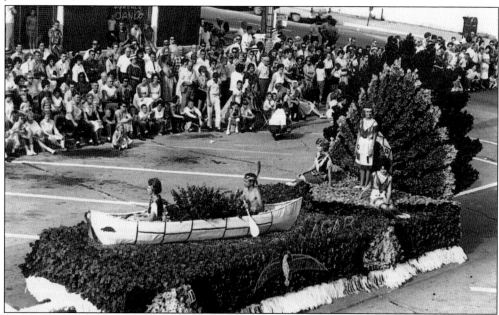

AGAR ENTRY. Many local citizens will recall the beautiful entries of Agar and other larger companies in Momence in past years. This entry is memorable and stunned the local crowd that year with its majestic and deep red flower design. Momence's tie to American Indian heritage is represented in this float. The old bank building still sports the clock at the corner of Washington Street and Dixie Highway. Note the young men standing on the window's ledge to get a better view. (Courtesy of the Edward Chipman Library.)

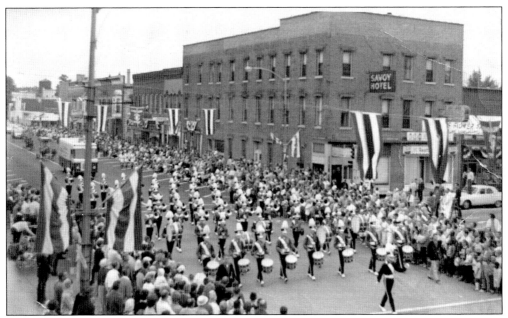

BIG AND BRASSY. The Chicago Cavaliers prepare to cross Dixie Highway toward an excited crowd. This perennial winner always had a certain swagger and was considered the "Darth Vader" of the Momence Drum Corp Show. It could be said that Momence's crowd favorite in those days was the Madison "Boy" Scouts who thrilled local audiences but always seemed to come up short against the "Green Machine." (Courtesy of Brian Prairie.)

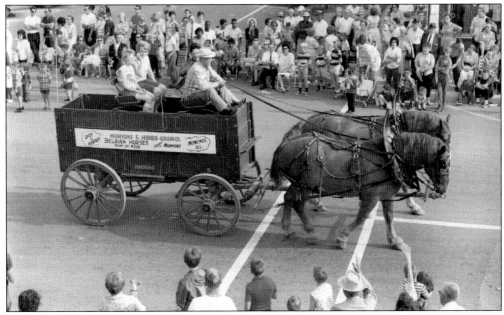

MUNYON AND HIBBS. The festival always had its share of fine equestrian entries. Most striking was this entry from local operators, which included a grain wagon promoting their local agricultural business. Note the wave of the enthusiastic couple at the bottom and those sitting in the middle of Dixie Highway, which was closed for the parades despite being a state highway. (Courtesy of the Edward Chipman Library.)

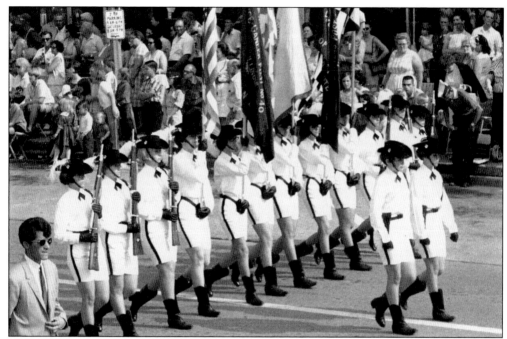

NATION'S BEST. The national champion White Tornados from Momence march down Washington Street to the adoring crowd demonstrating the precision that won them so many contests. Note the veteran in the background who has just saluted the colors and is adjusting his trousers to take his seat again on the curb. While it was a bit more sporadic then, standing for the colors has occurred consistently following the Iran hostage crisis and to this day. (Courtesy of Bill Buck.)

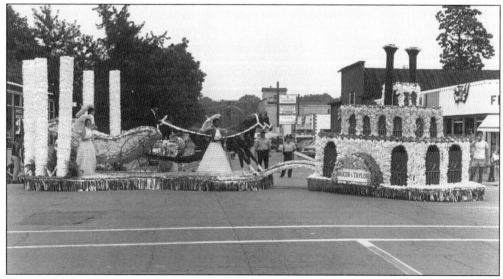

B AND T'S BEST. Everyone looked forward to the entry by Baker and Taylor each year. The company had a number of talented people that built the company float during the 1960s Here a double float makes the turn onto Washington Street under the watchful eye of local security. Momence produced an unusual amount of talented people either as a result of the festival or as a necessity to its creation. (Courtesy of the Progress Reporter.)

AMSTERDAM. Many Momence residents tried their hand at the various Gladiolas Festival flower shows over the years, which have been held at the high school since its beginning. Men, women, boys, and girls all participated, and some of the more creative entries were from unsuspecting sources. Here a winner admires her ribbon at the annual show. (Courtesy of the Progress Reporter.)

HOLLYWOOD HONOR. The thrill and surprise of winning best in a category is expressed by this younger winner's smile. The thrill of entering the show was matched only by the tremendous lift one received by winning an unexpected honor. The tradition of the flower show continues and has been passed down from generation to generation in Momence. (Courtesy of the Progress Reporter.)

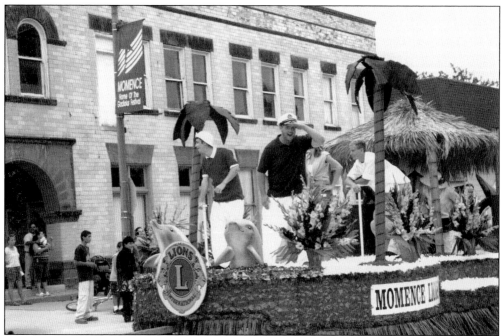

TELEVISION TIME. Each year has its humorous float entry. Many are quite clever and are designed by local volunteers. Here a very recent popular entry depicts the popular television show *Gilligan's Island*, complete with local Momence look-a-likes who hammed it up all the way down the parade route. (Courtesy of the Progress Reporter.)

FAMILY SPOT. Every family has its spot along the parade route. Family volunteers who agree to save seats for the other family members mark off territory early in the afternoon. The Gladiolas Festival is a homecoming for Momence. Traditionally Momence people come home for the holidays and they come home for the festival. Here the family of Marilyn "Mal" Peterson awaits the start of the parade. (Courtesy of Marilyn Peterson.)

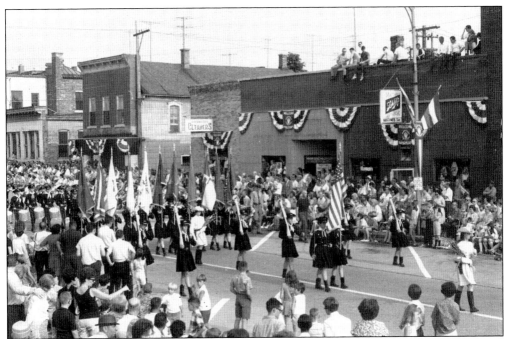

TROOPERS TROOP. One of the more popular drum corps of the day, the Troopers from Casper, Wyoming, march down Washington Street to a thrilled crowd. In 1967, the top four drum corps in the nation that year were also the top four at the Gladiolas Festival. Units from the entire country passed through the Gladiolas Festival in those days. (Courtesy of Brian Prairie.)

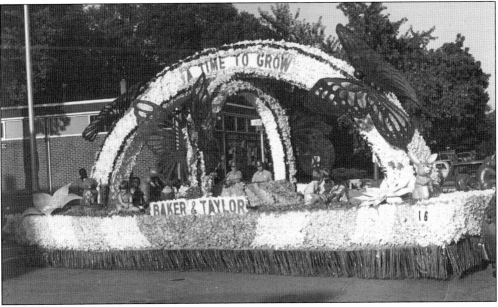

WASHINGTON TURN. Another entry from Baker and Taylor navigates the turn onto Washington Street in the 1970s. As the gladiola growing industry faded from the Momence area in later years, gladiolas were sometimes imported from elsewhere and more paper floats entered the event. Some used a combination of flowers and commercial float materials, but the tradition continues today. (Courtesy of the Progress Reporter.)

PIPES. Bagpipes grace the Gladiolas Festival as parade watchers look on. Numerous performing groups from around the Chicagoland and northern Illinois region participate in the annual August event. As drum corps and local high school bands diminished in availability, other groups began to fill the void. (Courtesy of the Progress Reporter.)

CAR SHOW. The annual car show on Island Park has been a very popular addition to the festival for a number years. Local antique car enthusiasts formed a local chapter of collectors and created a very popular event for the festival. A large flea market was also added and draws thousands to the festival each year. (Courtesy of the Progress Reporter.)

BORDER TOWN. Momence is a wonderful town with a rich history, strong determination, and a down-to-earth sense of how life should be enjoyed. The marquee on the edge of town welcomes new visitors to Momence everyday. It is fitting that the "Old Border Town" motto is displayed along with dates for the next festival. These two personalities of Momence will always be part of its future. (Courtesy of the Daily Journal.)

Discover Thousands of Local History Books
Featuring Millions of Vintage Images

Arcadia Publishing, the leading local history publisher in the United States, is committed to making history accessible and meaningful through publishing books that celebrate and preserve the heritage of America's people and places.

Find more books like this at
www.arcadiapublishing.com

Search for your hometown history, your old stomping grounds, and even your favorite sports team.

Consistent with our mission to preserve history on a local level, this book was printed in South Carolina on American-made paper and manufactured entirely in the United States. Products carrying the accredited Forest Stewardship Council (FSC) label are printed on 100 percent FSC-certified paper.